A Bountiful Harvest

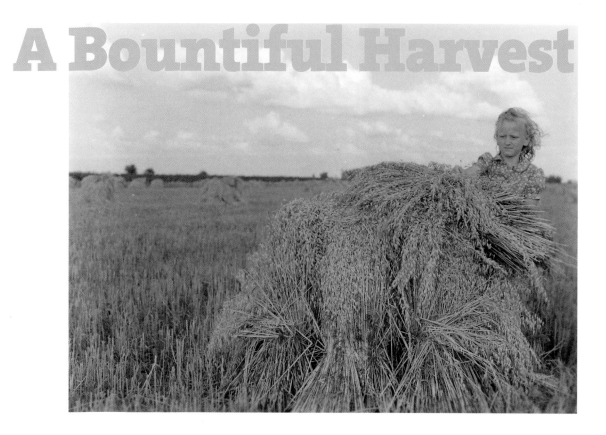

 A Bur Oak Book

The Midwestern Farm Photographs of Pete Wettach, 1925–1965

by Leslie A. Loveless *foreword by Christie Vilsack*

UNIVERSITY OF IOWA PRESS Ψ IOWA CITY

A Bountiful Harvest

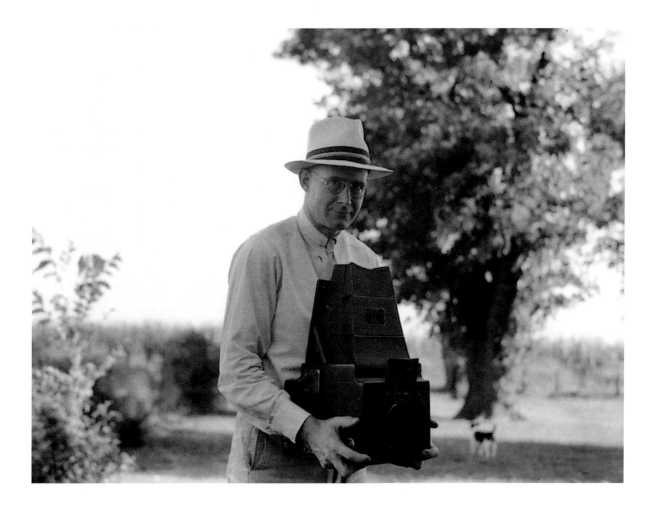

University of Iowa Press,
Iowa City 52242
Copyright © 2002 by the
University of Iowa Press
All rights reserved
Printed in China
Design by Richard Hendel
http://www.uiowa.edu/~uipress

Jacket photo: Unaware that she is being
photographed, Marie Swenson helps her father
shock oats on their farm eight miles north of
Mount Pleasant, Iowa, in the early 1940s.

The publication of this book was generously
supported by the University of Iowa Foundation
and the State Historical Society, Inc.

Printed on acid-free paper

Library of Congress
Cataloging-in-Publication Data
Loveless, Leslie A., 1961–.
 A bountiful harvest: the midwestern farm
photographs of Pete Wettach, 1925–1965 /
by Leslie Loveless; foreword by Christie
Vilsack.
 p. cm.—(A bur oak book)
 Includes bibliographical references and
 index.
 ISBN 0-87745-813-8 (cloth)
 1. Photography of farms—Iowa—
History—20th century. 2. Photography,
Agricultural—Iowa—History—20th
century. 3. Farm life—Iowa—History—
20th century—Pictorial works. 4. Iowa—
Social life and customs—Pictorial works.
5. Wettach, Arthur Melville, 1901–1976.
I. Wettach, Arthur Melville, 1901–1976.
II. Title. III. Series.
TR739.5 .L68 2002
779′.963′09777—dc21 2002019175

03 04 05 06 C 5 4

TO DAVID : *my partner, my sweetheart, my best friend*

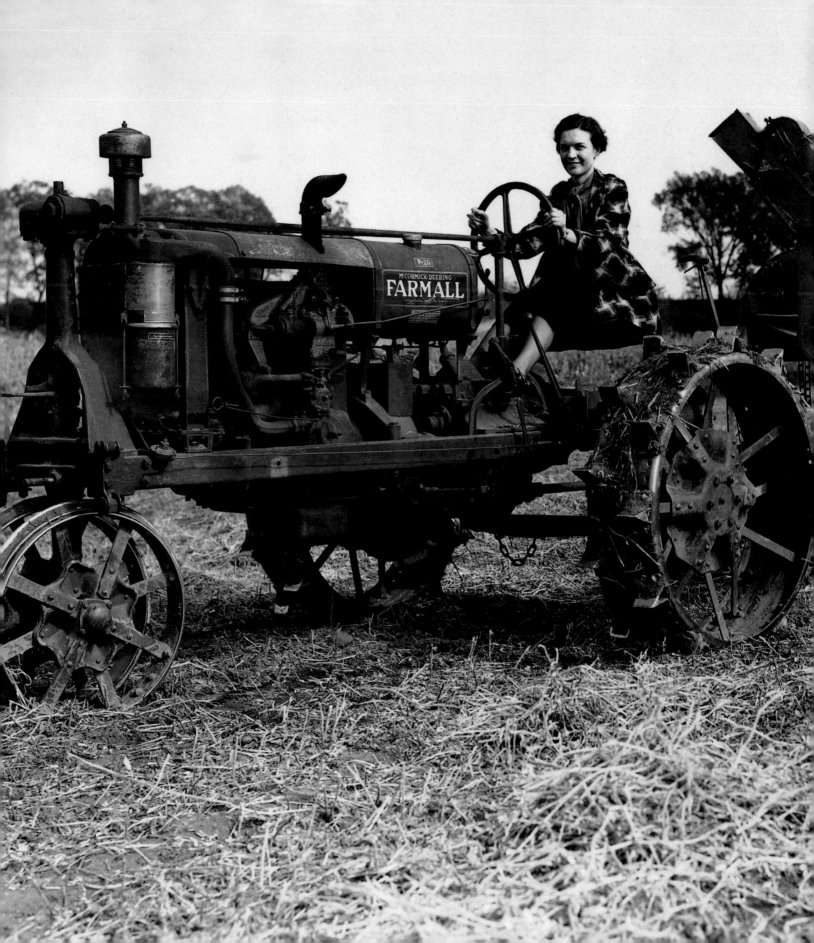

Contents

Foreword

I knew Pete Wettach as my father's client and the father of our family doctor in Mount Pleasant, Iowa. I can hear my dad, a local attorney, referring to Pete as "a good guy and a good Democrat." He was one of a number of grownups who were part of my parents' world. I knew he was a photographer whose studio was in the basement of Dr. Wettach's office, right next to the public library, but I had never seen any of his work. Unlike the commercial photographers in Mount Pleasant, who took color photos for yearbooks and weddings, Pete never displayed his work in his studio windows.

I first experienced Pete's black-and-white photography when I opened a complimentary copy of *Iowa Heritage Illustrated* in the spring of 2000. I was enchanted by his photos of Iowa country families, especially the children. "How had I escaped knowing about these photos?" I wondered. I read the article written by Leslie Loveless to discover that Pete Wettach had died in 1976, soon after we moved back to Mount Pleasant to work and raise a family. I was teaching then and my husband, Tom, was practicing law with my dad. One of Tom's first assignments involved solving some problems connected with Pete and Ruth Wettach's estate.

Through her book, *A Bountiful Harvest*, Leslie Loveless has given me a chance to get to know Pete Wettach as if he were still living in Mount Pleasant and telling his rural Iowa stories through the lens of his camera. Leslie frames the photos in the context of the Depression and the Roosevelt years, when Pete worked with Iowa farmers struggling to survive. She helps us understand that Pete was motivated as much by a genuine regard for his subjects as he was by artistic ambition. His respect for the people he served is evident in his composition and attention to detail, and their trust in him is evident in their eyes.

His photos and Leslie's text will help us understand how place and landscape influence our values and the way we see ourselves. When I study Pete's landscapes and portraits, I see both myself and the Iowa that Tom and I love reflected there. Many of the children Pete Wettach photographed are still living and working in Iowa. Some of them still live on the farms that Pete helped their families purchase through his work for the Farm Security Administration.

During the summer of 2001, I selected photos from the Wettach collection for public display at the governor's mansion at Terrace Hill in Des Moines. With the help of the Institute for Rural and Environmental Health at the University of Iowa and the State Historical Society of Iowa, we invited some of the subjects of the photos along with Pete's son and his grandchildren and great-grandchildren, who all live in Iowa.

The exhibit sparked storytelling sessions. One visitor told his son about the day a draft horse got its tail caught in the threshing machine. The subject of a photo of a family dinner recalled her resentment at having to serve her brothers and father before she sat down to eat.

The Terrace Hill exhibit was a debt of gratitude I owed Pete Wettach. We sometimes fail to recognize or celebrate the talents of those who live among us. The governor and I are honored to celebrate Pete Wettach's skills as an artist and a historian. He is a credit to our hometown and to our beautiful state.

Christie Vilsack

Acknowledgments

The writing of a book is usually a solitary effort but, while I certainly spent many weeks trying to keep my family, friends, and coworkers from luring me out of seclusion, this book was clearly a group project. I was just the one who was lucky enough to get the job of putting the words on the page.

Of all who took part, no one deserves to be singled out for his generosity of spirit more than Robert Wettach. He remained patient and helpful despite my incessant and probing questions about his memories of his father, tracked down and asked old neighbors and friends questions when he couldn't answer mine, identified innumerable photographs, and regaled me with more information about farming practices and familial connections among rural neighbors than I could ever hope to retain. Most of all, Dr. Wettach recognized the value of his father's life work and understood its importance to future generations. His donation of the bulk of Pete Wettach's work to the State Historical Society of Iowa was an act of great love both for his father and for the people who will enjoy his father's photographs for generations to come.

Without Mary Bennett's wisdom and enthusiasm, however, this book project never would have gotten off the ground. As the coordinator for special collections at SHSI, Mary brought decades of experience with historic photos to validate what I felt intuitively — that we had struck gold. She moved heaven and earth to make a home for the Wettach collection in the SHSI archives, committing staff time and resources so that I could research the collection without putting the fragile negatives and prints at risk. She was a constant source of ideas and guidance throughout my research and writing, encouraging me to keep at it even when I felt hopeless about ever finishing. Through Mary, I gained access to several dedicated staff members and volunteers: Natalie Benton, who diligently worked to archive the collection and has probably seen more of Pete Wettach's photos than anyone else; Roy Hampton, retired farmer, amateur photographer, and SHSI volunteer, who helped us city folks figure out what was what; Ginalie Swaim, who, as editor of SHSI's quarterly magazine, guided me through the process of writing an article about Pete Wettach and encouraged me to make the leap to a book-length effort; Matt Schaefer, who kept his sense of humor through my countless requests for assistance; and many

others, including director Shaner Magalhaes, Spencer Howard, Eric Lana, and Jamie Beranek.

Iowa's First Lady, Christie Vilsack, was a godsend to this project. Her sponsorship of an exhibit of Wettach's photographs at the governor's mansion at Terrace Hill in July 2001 brought public attention to this newly found collection. Many people who knew Pete Wettach came forward as a result of this exhibit, adding their recollections to my research. She and Governor Tom Vilsack, as well as the Terrace Hill staff, including Cyndi Pederson and Dave Cordes, helped make the exhibit a smashing success.

Lennis Moore of the Midwest Old Threshers Museum and his staff and volunteers provided unparalleled information on tractors, implements, and overall farm life during the period covered in this book. Lennis very generously loaned me their entire collection of Wettach prints for the duration of my research and helped correct factual errors in the book manuscript. Roy Reiman of Reiman Publications gave me free access to their stock of Wettach prints, and Trudi Bellin made me feel comfortable and welcome during the days I spent at Reiman's Milwaukee facility. Staff members at the National Archives Records Administration in both Kansas City and Chicago were attentive, patient, and helpful.

Faculty and staff members at the University of Iowa, including the College of Public Health and particularly the Institute for Rural and Environmental Health, contributed to this project in many different ways. Craig Zwerling, head of the department that houses the institute, immediately saw the potential impact of the Wettach collection and encouraged me to write a book. He secured the necessary funding and made sure that I had the time I needed to see it through to completion. Dan McMillan, who found the first stash of Wettach negatives, was a constant source of encouragement and enthusiasm, as was Dean James Merchant of the College of Public Health. Faculty and staff from Iowa's Center for Agricultural Health and Safety and the Great Plains Center for Agricultural Health, particularly Kelley Donham and Risto Rautiainen, helped me check facts and find resources. Rachel Villhauer worked cheerfully for months to enter information into a database of thousands of Wettach's photos so that I could keep track of them all. Larry Prybil and Chris Goodale worked hard to find financial support for the project. Del Bonney was a dream come true, picking up many of my projects so that I could focus on finishing the book. Zach Gorman designed a beautiful web site. John Raeburn, professor of American Studies at the University of Iowa, was both generous and patient, providing me with a wealth of information and ideas about the history of photography as well as a valuable critique of the book manuscript.

Many, many individuals shared their personal stories and memories to help make Pete Wettach's photographs come alive, including Marie Swenson Johnson, John Vermazen, Caroline Jorgensen Engdahl, Mabyn Jensen Fox, Verana Grant Johnson, Loren Nolting, Thelma Coon, Patricia Bryant Doak, Geraldine Middleswart, Mary Nau, Kenneth White, Pauline Payne, Frank Marshall, Marjorie Brown, Beverly Brown Hamm, Robert Triska, Jan Triska Moxley, Leila Williams Carlo, and Catherine Seyb. Max Henryson shared his memories of his work as a Farm Security Administration county supervisor in southwestern Iowa and read through the book manuscript for accuracy. Catherine Miller of the Farm Bureau and the members of the boards of the Lee, Henry, Des Moines, and Jefferson County Farm Bureaus were invaluable resources for photo identification and background. Dot Hellkamp, Norma Schweitzer, Valeen Ziegenhorn, and Joe Nolte, all staff or volunteers with various history-oriented organizations, helped me track down facts and sources. Hank Louis, of Henry Louis/Photoworld, Inc., in Iowa City, helped me understand the Graflex camera Wettach used, as did Les Newcomer, an amateur Graflex enthusiast. Tory Lane and Jay Bordage generously loaned me their 4 x 5 Graflex to try out for myself.

Holly Carver, director of the University of Iowa Press, recognized the potential of the Wettach collection and provided me with guidance and encouragement from the very beginning. I am so grateful for Holly's constant support, warmth, and sense of humor through even the most difficult parts of this process.

Finally, I thank my husband, David Forman, for his unflinching enthusiasm for this project. He read drafts, washed dishes, brainstormed, put the kids to bed, sorted through photos, and dried my tears, all while carrying his own impressively heavy load as a graduate student. No one did more to help me keep my momentum going.

Research for this book was supported by the Institute for Rural and Environmental Health and by grants from the Heartland Center for Occupational Health and Safety (via the National Institute for Occupational Safety and Health) and the University of Iowa's Arts and Humanities Initiative. The contents of this book are solely the responsibility of the author and do not necessarily represent the official views of these organizations.

Costs for the printing of this edition of *A Bountiful Harvest* were supported in part by a generous gift from Robert S. Wettach, M.D.

Introduction

In the winter of 1999, a departing coworker handed me six small yellow-orange boxes, the contents of which would lead me to an astonishing treasure.

The coworker was Dan McMillan, an editor at the University of Iowa's Institute for Rural and Environmental Health. With experience as a reporter and freelance writer, I had been hired only a few months earlier to assist him with the production of various publications. Dan was moving out to take a better job and I opted to move into his office, deciding that the view of a distant hayfield was more appealing than my current close-up look at a bunch of parked cars. Dan cleaned out the shelves and cabinets for me before I moved in. It was then that he found the boxes.

The editor's job was a combination of writer, designer, and overall presentation "helper" for faculty, staff, and students. Since much of the academic research and outreach had to do with rural communities and agricultural health and safety, it was not surprising to find photographs of farm scenes stored in an office devoted to publications. We used pictures like these routinely in newsletters, brochures, and slide shows. What was surprising was how old, and how beautiful, they were.

Each box contained between a few dozen and two hundred black-and-white negatives. Two of the largest boxes contained negatives that were 5×7 inches in size. I had several developed to get a better look at them. The images were all taken on farms and looked to be from the 1930s or 1940s. Other than that, the subject matter was varied: a boy working in a garden, a group of people threshing, a muscular man in overalls holding the reins of two horses, a woman pulling a bucket from a well, two men smiling atop a very early combine, and more.

I had never seen negatives this large before. Even the smallest of them were some 3×4 inches in size. Nor had I ever seen images that were so captivating. I have always liked older, black-and-white photographs, especially of people and a way of life long gone. I gravitated toward old photos at museums and at friends' homes, imagining what the people in the pictures were like and feeling an urgent need to know their names and other details about their lives.

The images in these small boxes were particularly intriguing. The large-format negatives revealed a lot of detail in every image. Even an ordinary shot of a farmer on a tractor offered crisp textures in the crop growing up from the ground and the smooth metal of the machine under soft clouds. The photographer had an impressive talent for composition — nearly every photo begged to be framed. But what struck me most was the sense of warmth and camaraderie projected by the people in the photographs. It was as if they knew the photographer well and welcomed his presence. As a viewer more than half a century later, seeing what the photographer saw through the camera lens, I felt as if their open expressions were directed at me.

The boxes that held the negatives were the distinctive yellow-orange Kodak color, with the Kodak logo printed on the outside. The company used these boxes to sell sheet film. Someone had made another use for them, however. On the side of each box was a heading printed in black felt-tipped marker, such as "THRESHING," "HANDY," "HORSES," "CORN." On the top of one of the boxes was pasted a preprinted label that read:

A. M. Wettach
Agricultural Photographer
Mt. Pleasant, Iowa

This find created a little stir at the institute. Not only were these photos visually striking, they also offered a close look at a pivotal era in the history of the family farm. They showed how diversified midwestern farms once were and how every member of the family participated in the work. There were photos of farms with crops of corn, oats, clover, wheat, sorghum, and rye. There were small numbers (by today's standards) of many different kinds of farm animals, including hogs, chickens, dairy cows, beef cattle, sheep, geese, turkeys, horses, and mules. Machines, work animals, and large groups of people — children, old people, women, and men — were shown working together. There were photos of early tractors and the first combines, both of which revolutionized farming but also, along with other new technologies, changed the face of farming communities forever.

It was already obvious to me and to some of my coworkers that the photographs in these six boxes had much to offer toward an understanding of how the realities of rural farming communities had been shaped over the past century. With the blessing and encouragement of department head Craig Zwerling, I started asking questions. If we could figure out where these photographs came from, we could put them together for book publication.

I started with the surname Wettach. It was unusual enough that I figured I might have a chance of finding a relative or even the photographer himself if he was still living. Having relocated to Iowa City from Boston three years earlier, I was not terribly optimistic. Finding someone from a vague clue that was many decades old would have been very difficult in the dense, mobile populations that characterize the East Coast. It had not occurred to me to expect anything different in Iowa.

Within minutes, however, I found a listing for Robert Wettach, a family doctor in Mount Pleasant. And, much to my astonishment, I was able to reach Dr. Wettach on the phone without much difficulty. A. M. Wettach, also known as Pete, he told me, was his father. He had died some twenty-three years earlier. Moreover, Dr. Wettach had kept his father's entire collection of negatives and some prints in his basement for all these years, thinking they might be of some value, but he had never quite known what to do with them.

"There are quite a few boxes down here," he said. "You might want to come down and take a look at these for yourself."

I contacted Mary Bennett, an archivist and the coordinator of special collections at the State Historical Society of Iowa in Iowa City, and together we made the fifty-mile drive south to Mount Pleasant, a town of about eight thousand. We found a section of Robert Wettach's basement filled with the same kind of yellow-orange boxes, double-stacked on shelves from the floor to the ceiling. They were all labeled with felt-tip marker, stored in alphabetical order from "AAA" (Agricultural Adjustment Act) to "WORLD'S FAIR." There were hundreds of boxes, most with a hundred or more negatives. There were easily thirty thousand negatives — probably more. We pulled a few out at random and held them up to the light. They looked as breathtaking as the ones found in my office.

Dr. Wettach's basement also had some large cardboard boxes filled with prints. Unlike the negatives, they were unsorted, and there were far fewer — only about two thousand. But they had one element that the negatives did not have: most had detailed captions on the back. Mary immediately recognized the value of the captioned prints and was very excited to find them. The information written on the back would provide valuable clues about the whos, whats, wheres, and whys of the negatives.

Relieved to find a good home for them, Dr. Wettach (who pronounces his family name WET-tack) agreed to donate a portion of his father's prints and negatives to the historical society. He also put us in touch with Lennis Moore, the director of Midwest Old Threshers, a well-known agricultural history museum that happens to be located in Mount Pleasant. With the news that someone was interested in writing a book, Lennis

generously loaned me several hundred prints that had been donated to the museum's archives after A. M. Wettach's death. Mary and I packed up our booty and headed back to Iowa City.

And so the real work began. Mary's staff at the historical society began the painstaking process of cleaning, sorting, and housing the negatives and prints. I began trying to make sense of the pictures. The number of images was quite overwhelming, and so was their subject matter. Some of the photographs seemed very technical. There were endless pictures of countless different models of tractors — a feast for the Midwest Old Threshers types, but a mind-boggling project for this city slicker. Some of the photographs, however, seemed like pure art. Among my favorites was one of a young girl lifting a bundle, or shock, of freshly cut oats. The textures in this picture were beautiful. The oat shocks were crisp and bright, the vista behind the girl was broad, and the girl herself, wearing a little summer dress, had a look of careful concentration beyond her years. Unfortunately, the print had no caption on the back, so there was no way to identify the little girl or to tell where or when the picture was taken.

It would have been very easy to sit in the historical society reading room day after day and allow myself to be mesmerized by Wettach's thousands of photographs, but I had to get organized. I made several goals for myself and for the book. First, I needed to learn more about this period in history and about farming in general. Second, I had to figure out a way to share the photographs, which so vividly describe this era, with people who may or may not have lived it themselves. Finally, and most urgently, I had to raise some money to get the book written and published.

One of my early prospects for my third goal was the Farm Bureau. I scheduled visits to several different county Farm Bureau meetings scattered around southeast Iowa and brought along some notebooks full of Wettach prints to pass around to help my pitch for funds. At one meeting, a woman in her sixties froze over one small photograph. "That's me!" she gasped. She was the little girl shocking oats; she had never seen the picture before.

It may be difficult for a reader who has never lived in or near a small, agriculturally based community to understand the deep, long-term connections farming people have with each other and with the land. Even in the twenty-first century, even in our increasingly mobile society, even when children grow up and move to cities, there is still a critical mass of people who stay in the area and who know each other and each others' parents, children, and grandchildren. If I had understood this better at first, I might not have been as stunned as I was that evening, or I might have written it off as an unusual coincidence. But it kept happening.

As I went around to other Farm Bureau board meetings, people continued to recognize photos. At almost every meeting, each in a different county thirty or fifty miles from the one before, attendees found photographs of their parents, themselves, or both. They would laugh and regale me with stories: "This one was taken when the farm first got electricity." "That's my mother washing dishes, in her best apron. I'll bet you don't even *own* an apron!" "I know this place — the barn was destroyed by a tornado. The same thing happened to me twelve years ago." These were very small groups, maybe a dozen people at most, looking at only one or two hundred randomly selected prints. I began to wonder what would happen if Wettach's photographs were ever published in a broader venue.

My experiences with the Farm Bureau boards helped me begin to realize that there was more to this collection than just the pictures. The chance encounters, the ease with which connections could be made, and the willingness of people to share their family stories caught me off guard over and over again. A short article in any local paper, even with only one accompanying photo, would get my phone ringing with calls from people who could identify the picture.

A year later, when I wrote an article about the Wettach collection for the spring 2000 *Iowa Heritage Illustrated*, the historical society's quarterly magazine, people responded again. An Iowa man saw his picture in the magazine while at his doctor's office. Others from as far away as California and Arizona wrote in after friends or relatives in Iowa sent them clippings. Within weeks, I had names and addresses for nearly all the subjects of the twenty-odd photographs in the article.

One coincidence with the Wettach photographs was political as well as personal. A few months before Dan McMillan cleaned out his office, a new governor was elected to the state of Iowa: Tom Vilsack, of Mount Pleasant, the first new governor in Iowa in sixteen years. Initially I noted that Governor Vilsack was from the same town as Wettach and hoped that he might someday have a polite interest in the project. But it turned out that he, and particularly his wife, Christie, knew the Wettach family quite well. Christie remembered Pete from when she was growing up. She was delighted to give an old family friend and neighbor the credit he deserved, hosting an exhibit of Wettach's photographs and a gala affair at Terrace Hill, the governor's mansion. Once again, people in the photographs (or their descendants) came out of the woodwork.

This book is as much a tribute to the people living today who have so much to share about this time and this way of life as it is to the man who helped record it in so much detail. I have come to believe that the kind of research I did for this project, which included locating and interviewing dozens of people who were photographed by Wettach, could not have been done among the more transient populations that have come to character-

ize large portions of the United States today. The timing of this rediscovery is also critical to its value. I am certain that my research could not have been done in this way twenty years later. The written records I used might still have been available, but I would not have been able to find most of the people whose personal memories have enriched our appreciation of these photographs.

I am not a native Iowan or a midwesterner. I am not a historian or a photographer. I have never lived on a farm. Nearly all the pictures in this book were taken before I was born. But these photographs struck a chord with me, bringing me back to look at them again and again. I have used my skills as a journalist and writer to bring the knowledge of the farmers, historians, photographers, and people who lived through these times to help understand the treasure that A. M. Wettach has left for us. I share what I have learned, not as an expert but as one person who loves these photographs. I hope you will love them as much as I do.

A Bountiful Harvest

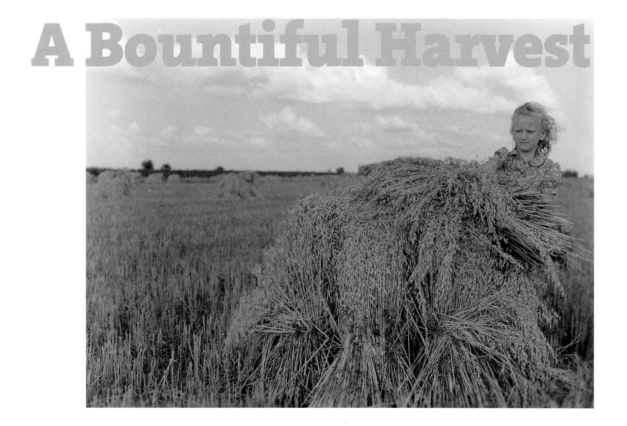

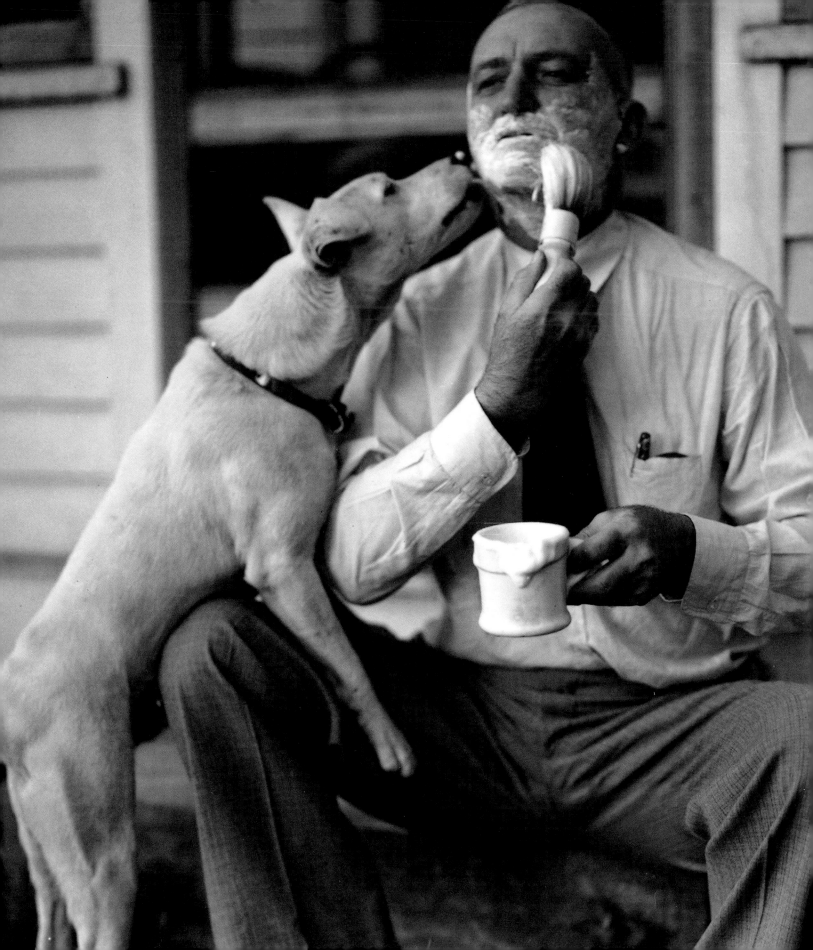

A Really Nice Paintbrush

On a crisp morning on the Williams farm in Henry County, Iowa, a familiar black Dodge coupe pulled up the drive. Out stepped a small man, dressed in business clothes and a fedora. He cradled a square black box under one arm.

Leila Williams knew him well. This was Mr. Wettach, from the Farm Security Administration office in nearby Mount Pleasant. In 1939, when she was only twelve, Pete, as her parents called him, had helped them apply for a government loan to buy a new farm. Now he was back for one of his regular visits to see how they were doing and, as always, he brought along his camera.

Leila loved their new home. Their old rented place, near Winfield, was run down and needed repairs and upkeep. Times being as hard as they were, her parents, David and Grace, could hardly believe it when they heard about the FSA's new program to help renting farmers buy their own farms. No one could get a loan these days — it was still the Great Depression — and it all seemed too good to be true.

But here they were, just a few years later, not only on their own place but, in Leila's opinion, on the best of all the Henry County farms that had been sold through the FSA program. The house was solid and the soil good. They had electricity and running water for the first time. She remembered her parents talking about how lucky they were to get

When tillage begins, other arts follow. The farmers therefore are the founders of human civilization.
Daniel Webster

the place that everyone wanted. The farmhouse was so nice that Mr. Wettach, who took photographs as a hobby, had sold a picture of it to a farming magazine and had also gathered all the local Tenant Purchase (TP) families together on the Williams's broad front porch for a group picture.

Mr. Wettach told them that they would have to keep careful farming records. They had to plant a garden for food and Leila's mother had to can a certain number of quarts to feed the family each winter. The Williams family grew corn, oats, and alfalfa on the 120 acres of farmland, working it with a team of horses, and they raised hogs and chickens. Leila's father hoped to buy a tractor soon. Mr. Wettach followed their progress, but also, with their permission, he took their pictures. The family was happy to oblige. Mr. Wettach was more than the FSA county supervisor. By this time, he was also a friend.

As he shook hands with her father and began to talk business, Leila hoped that Mr. Wettach would also have time to take some pictures that day. He seemed to have a lot of luck getting them published. It was exciting to see familiar places and people in *Wallaces' Farmer*, or in the *Farm Journal*, or even the *Mount Pleasant News*. Leila, who had kept a scrapbook since she was ten, pasted clippings of Mr. Wettach's pictures alongside wedding invitations, postcards, and other keepsakes. Sometimes he would make a print for the family to keep.

"Well, I need a picture of a girl collecting eggs," Mr. Wettach finally announced, looking in Leila's direction after he and her father had chatted for a while. Leila hesitated for a moment. She had already collected the eggs earlier that morning and placed them in the cellar in crates which they would use to take the eggs into town to sell. There weren't likely to be many more eggs. "That's all right," he smiled. "Just go down to the cellar and fill the bucket you usually use."

So she did. Returning from the cellar wearing a kerchief and a sweater against the chilly air and holding a tin bucket full of re-collected eggs, Leila saw Mr. Wettach standing outside the chicken house. The box that he had taken out of his car was now unfolded, looking a little like a pyramid. It was made of wood — mahogany, Mr. Wettach had once told her — covered with leather. He held the bottom of it low, down near his waist, and peered down through his glasses into the top, pointing the lens at the chicken house door. He fussed with some knobs, the hand holding the camera shaking a bit. The camera looked pretty heavy.

Leila walked into the chicken house feeling a little foolish, but then she relaxed. Collecting eggs was something she did every day. It would not be hard to pretend that she was doing it yet again. She turned around as if she had just filled her bucket, walking back toward the door. She looked up at Mr. Wettach, who was standing outside. As she walked

into the light at the door of the chicken house, something inside the camera made a loud, familiar *thwack* as he took her picture. Mr. Wettach yanked out a film holder and turned it around as he looked up and smiled. That was it.

This was how A. M. "Pete" Wettach, a self-described agricultural photographer, recorded in great detail the everyday lives of midwestern farmers from the Great Depression through World War II and the postwar years. By the time of his death in 1976, Wettach had taken tens of thousands of photographs, leaving an incomparably rich account of a way of life that is passing into history.

Wettach worked for the Farm Security Administration as a county supervisor in southeast Iowa during the 1930s and 1940s. A self-taught shutterbug, Wettach always brought along his camera as he traveled across the countryside visiting clients, documenting the profession of farming in the Midwest during a time of great change. As an agricultural photographer, he took pictures from the point of view of the farmer and sold them to farming magazines. His photographs show an intimacy and a familiarity with the subjects, who were frequently his friends, neighbors, family members, and clients. They celebrate farm life while also recording with staggering detail its social and technological changes.

Ironically, the FSA is now better known for its photography project than for its farm rehabilitation programs, including the one that Pete Wettach administered. The pictures taken by FSA photographers such as Walker Evans, Dorothea Lange, Russell Lee, Ben Shahn, John Vachon, and others appear regularly in museums and books to this day. Although the FSA photographers took a wide variety of pictures of both urban and rural life during the Great Depression and World War II years, the project is most often remembered for its documentation of the bleak conditions of the rural poor.

But Pete Wettach never worked for this division of the FSA. During the early part of his career, he was a photographer on the side — a hobbyist — who also happened to work for the FSA in an office job. Instead of touring the country on assignment, charged with documenting the harmful effects of the Depression and the Dust Bowl years as the FSA photographers did, Wettach was completely on his own. Even later in his life, when he left government work to become a full-time freelance photographer, he still lived among and worked with many of the people he photographed. Most of the FSA photographers never had the opportunity to get to know their subjects well. Wettach, on the other hand, often had known the people he photographed for quite some time; in many cases he took pictures of them over the course of one, two, or even three decades. What he shared with the FSA photographers was their employer's mission to improve the lot of the increasingly

impoverished farm family. What Wettach saw through the lens of his camera, however, as a neighbor and friend of some of these struggling families, would prove to be very different from what the FSA photographers saw.

Arthur Melville Wettach was born on June 21, 1901, and grew up in Caldwell, New Jersey. One of four children, Melville, as his parents called him, was raised in a moderately affluent home. His father, Archibald Wettach, was a Swiss immigrant who served as a general clerk of courts, and his mother, Carrie Stewart Wettach, was a descendant of Christian Sharps, of Sharps rifle fame.

As he grew, young Melville developed a fascination with rural life, particularly with farming. He resolved to learn as much as he could about farm life, even working at a local dairy during high school, but he also began to think about leaving New Jersey for a part of the country where he could live on the land. A spread about Iowa in *Country Gentleman* magazine captured his imagination and, when he learned that Iowa State College had a good agriculture program, he made plans to go west. (Fittingly, *Country Gentleman*, the magazine that brought him to Iowa, would eventually publish many of his photographs.)

Wettach arrived by train at Ames, Iowa, in 1919 at the age of eighteen with twenty-four dollars in his pocket, and enrolled in Iowa State College. There he met William Allen Jennings, a fellow student who would become a close friend. It was at his first meeting with Jennings that Wettach decided to change his own first name to Pete, hoping it would help him fit into his new home in Iowa better than the name Melville would. His new name stuck for life, as did the friendship. When Jennings decided to leave college to work on an invention — a steel cement form — Pete Wettach spent many hours helping him. For his efforts, he later received some stock in Jennings's new business, known today as Economy Forms Corporation.

It was also during his college years that Pete met the young woman whom he would eventually marry: Ruth Grimes. Raised on a farm near Montrose, a small community of about 1,300 in Lee County in the far southeastern corner of Iowa, Ruth was studying home economics at Iowa State College. After Wettach graduated in 1923 with a degree in animal husbandry, Ruth's family provided him with his first real taste of farm life as he spent the next year on the Grimes farm. Wettach farmed with Ruth's father, Robert Reed Grimes, while she completed her studies.

Ruth and Pete married in 1924, moving back to Ames when it became clear that the Grimes's farm earnings were insufficient for two families. In addition to teaching science at the local high school, Wettach also began writing and selling articles, mostly about

agriculture. He would return to Montrose again in 1925, staying for almost a year, when Ruth's father became too ill to farm alone. Ames High School held Pete Wettach's position open and handed him a raise upon his return.

While he was helping on the Grimes farm, Wettach found time for another pursuit: photography. He took pictures of farming activity in and around Montrose, probably using a basic camera for amateurs that was available in the 1920s. It may have been the same camera that he and Ruth brought along on car camping trips with W. A. Jennings and his wife, Lillian, using it to take pictures of picnics and pretty scenes.

Even if the camera was not particularly fancy, Wettach made good use of it. He apparently did not have a darkroom to develop his pictures then — the photographs that survive from this period all appear to have been commercially developed — but he clearly liked some of the photos enough to save the negatives for making prints when he could have his own darkroom. His knack for photography began to attract attention. In September 1927, in a letter to his parents, Wettach wrote: "Got $28.00 from some articles and $6 coming from a photo contest in the local paper." He had won first place in a farm photo contest sponsored by the *Ames Tribune*. Unfortunately, the *Tribune* did not print or describe the winning photo, so Wettach's first success with agricultural photography is probably lost.

In 1928, the Wettachs' first and only child, Robert Stewart Wettach, was born. Later that year the family moved to New Hampton, Iowa, where Pete took a job teaching vocational agriculture in high school. Pete's yearly salary was $2,400, a decent income for a teacher at that time.

After just one academic year, the Wettachs decided to leave New Hampton to finally fulfill Pete's longtime wish to be a farmer. They moved to a farm near Montrose, first renting the "Curtis place" three miles south of town and a quarter mile from Ruth's parents. There they farmed with the Grimes family. Two years later, they rented the "Cooney place," a little farther away, but still near Montrose.

Ruth and Pete set up a farm with a variety of animals and crops typical of this era in the Midwest: cows, chickens, and hogs that would provide food for the family along with a little extra income from the sale of cream, eggs, and meat; work horses; corn, oats, and hay for the animals; and a family garden. They did not have a tractor, electricity, or indoor plumbing; water came from an outside pump; and the toilet — well, a privy, actually — was in an outhouse. They had an automobile and, like many Iowa farmers then, they probably had a telephone and a battery-operated radio to help keep them connected to the world outside the farm. They planned to share resources with Ruth's parents, helping out when needed and using the Grimes' farming equipment in some cases rather than

purchasing their own. The Wettachs also decided to specialize in raising turkeys and in growing popcorn for some cash income. Pete, Ruth, and Bob — still a baby then — began their new life on the farm in the spring of 1929, only a few months before the stock market crash that would usher in the Great Depression.

Pete Wettach's dream of farming was doomed almost from the very beginning. The 1920s had not been particularly prosperous times for farmers, but prices bottomed out so precipitously in the early 1930s that many farm families faced grinding poverty. Along with the Depression came the natural calamities that would add insult to injury for midwestern farmers. Although Iowa did not experience the extreme Dust Bowl conditions that devastated some of the Plains states, it was ravaged by insect plagues, including grasshoppers and chinch bugs, and by drought, dust storms, and the annual parade of windstorms and twisters typical of the Tornado Alley region of the country's midsection. Even though he was a very young child at the time, Bob Wettach remembers a dramatic storm at the Cooney place.

"I'm not even sure if this [was] day or night, but I remember it being dark and we went down into our cellar. My mother wrapped me up in [a blanket] as we ran down the stairs, slamming the door behind us, and one corner of the blanket dragged across the floor. . . . As we sat down she flipped the blanket around and the wet blanket corner hit me right in the face! I think I was too frightened to cry because I knew my mother and father were frightened and I heard this terrible sound like a freight train . . . going through with no whistle, but going fast, at least 50 or 60 miles an hour. . . .

"Sometime later when we came out in the daylight the barn was gone. The shed where we kept the car was gone. There was wreckage around and I remember seeing several chickens running around with just a few feathers left and all the rest of the feathers were missing, having been blown off."

The storm that Bob remembers occurred on June 17, 1932, when he was four years old. The *Gate City Times*, a Keokuk daily, reported a substantial windstorm "of tornadic proportions" affecting many towns in the area, and the state climatologist records reported "considerable wind damage" and "several farm buildings blown down in the countryside" near Montrose.

Despite the constant difficulties, sometime during these years Pete scraped together the money to buy the secondhand camera that he would use for much of his early career, taking some of his most striking pictures with it. He wrote later: "I bought a used 5 × 7 Graflex camera while we were on the farm and tried to learn photography by trial and error and reading. Without electricity and running water it was slow going." This camera, most likely a Graflex 5 × 7 Series B, exposed large negatives of 5 × 7 inches, allowing for

great detail and beautiful quality. It was a camera for serious photographers and photo-journalists, one that would help Wettach take much better photographs than he had been able to before. It was extraordinarily cumbersome to use by today's standards, however. The camera was heavy and large, weighing eleven or twelve pounds. When not in use, it looked like a black, leather-covered wooden box roughly the size of a modern car battery. The large viewfinder unfolded on the top, while a lens protruded from a trap door in the front. A photographer would have to look down into the viewfinder to see the subject, which was reflected by means of a large mirror facing the lens.

Only one photograph could be taken at a time. The camera came with a film holder that could accommodate two sheets of film, for two photographs. The film holder had to be taken out, flipped around, and reinserted into the back of the camera between shots. Wettach may have had several of these holders — which had to be preloaded with film in a darkroom and carried in a black bag to prevent light leaks that would spoil the film — or he may have had a film magazine that could hold a maximum of twelve sheets of film. The camera had no light meter (they had yet to be invented) and no flash attachment. A brass plate on the side provided a lookup table to calculate exposure time. Film speed, not yet standardized, varied depending on the film manufacturer.

To take a picture with a 5×7 Graflex Series B, Wettach would have had to balance this heavy box with his left hand at waist height, adjusting the aperture and tension with his other hand, all while looking down into a viewfinder that offered a reversed image of the subject. Figuring out the proper shutter speed was an exercise in educated guesswork. Wettach would not have been able to take a vertical shot, since the camera could not be turned on its side without great difficulty, unless his camera had a rotating back that allowed the film to be turned sideways. He would have to spend at least fifteen to thirty seconds to reset the camera after every shot. And, unless he had a black bag or box for loading film, he would not have been able to take more than one or two dozen pictures without returning to his darkroom — often a long drive over rural roads — to reload film.

Indoor shots also must have been challenging. Since many of his subjects lived on farms that did not have electricity, he would not have been able to use plug-in floodlights. One approach would have been to take a long exposure, but that would require a subject that did not move for a while. He might have used a separate, hand-held flash, but to do so he would have needed an extra pair of hands or a tripod.

Despite the painstaking work involved, Wettach took thousands of photographs with his 5×7 Graflex. Of the tens of thousands of Wettach negatives now housed at the State Historical Society of Iowa, about 4,200 are in this format. Most of the remainder are 4×5 inches in size, taken by a smaller Graflex or similar format camera. Wettach

owned several other cameras during the course of his career, including a Hasselblad and a 35mm Leica.

Despite the relatively primitive conditions on the farm, once Wettach purchased his Graflex camera, he began to experiment with photography, reading manuals and magazines and teaching himself to take pictures, develop the film, and make his own prints. As Wettach's skills with photography improved, he began to submit his photos to magazines that already regularly bought his articles. He continued to make most of his freelance income from writing, but every now and then over the next few years the Wettachs' farm account book would show some income from photos. The first record of a photo sold after he began farming was on February 7, 1930, when he earned seventy-five cents from *American Farming* magazine.

Even with the potential for extra income, however, Pete Wettach likely had only limited time to spend taking pictures during those years on the farm. Whether or not the 1932 windstorm was a factor, the Wettachs' financial situation deteriorated that year. Their farm records show many purchases for household items "on account," rather than paid for in cash as they had been in the past. The Wettachs were also forced to borrow from friends and family. Pete's family back east, always generous with small monetary gifts, loaned them some money: first $150 and later $500. By the end of that year, their situation had become so desperate that they even borrowed $200 from young Bob, who likely had savings from gifts from his New Jersey relatives.

When later asked by his employer, the Farm Security Administration, to describe his income during his farming years, Pete Wettach avoided being specific, citing economic depression, drought, and chinch bug years, and estimating a range of $700 to $2400 gross income. Throughout their farming years, the Wettachs had nonfarming income — including occasional cash gifts from New Jersey of $5 or $10 around holidays or anniversaries — and income from Pete's articles and photographs, which together sometimes amounted to more than $100 in a year. However, it never was enough to make ends meet.

The Wettachs simply couldn't make it in farming. In mid 1935, they sublet their land and Pete took a job as a county supervisor with the federal government's Resettlement Administration, an agriculture relief program that would, ironically, put him to work helping keep other farmers from going under as he had. His salary was $1,200, only half that of his last teaching position six years earlier. In December of 1935, Pete, Ruth, and Bob (now seven years old) left the farm for good. They moved some fifty-five miles north, to Mount Pleasant, Iowa, the seat of Henry County and the location of the Resettlement Administration's regional office, renting a place from the Nihart family at 209 North Jefferson Street.

In 1937 the Resettlement Administration became the Farm Security Administration, an agency of the Department of Agriculture. The FSA oversaw several farm relief programs, including one called the Tenant Purchase (TP) program, later called the Farm Ownership program, in which renting farmers could apply for government loans to purchase their own farms. During the Depression loans to farm families with few or no financial resources were almost unheard of. Not surprisingly, the TP program was popular and competition was fierce among renting farmers hoping to become owner-operators. Applicants to the TP program were carefully screened and, once approved, closely monitored. As an FSA county supervisor, Pete Wettach worked closely with the farm families in this program. His work took him out to many individual farms across a broad swath of rural Iowa. At one point his territory included nine counties (Lee, Van Buren, Henry, Des Moines, Louisa, Muscatine, Scott, Cedar, and Clinton), comprising a large portion of the southeastern quadrant of the state.

Once in Mount Pleasant, Pete Wettach began to take more photographs. He probably had more time, and a bit more cash for photographic supplies, than he had on the farm. He also undertook a more earnest effort to sell his photographs. Regular contact with many farm families through his FSA job provided plenty of subjects. Now that they lived in town, the Wettachs had running water and electricity, and Pete was able to make a more concerted effort to set up a darkroom. He took over the bathroom to develop and enlarge photographs, covering the windows with blankets. Robert Wettach remembers being forced to maintain considerable bladder control as his father's enthusiasm for photography grew.

With Pete in a stable job with the federal government, the Wettachs' financial situation eventually enabled them to build a home in Mount Pleasant. "We built our home at 706 North Main in 1941–1942 with a basement darkroom, complete with sink, enlarger, etc. I had been sending a few photographs to farm magazines and hunting them on weekends and vacations, and doing darkroom work mostly at night," Pete wrote. A few years later, Ruth inherited her parents' Montrose farm. It was sold, and some or all of the proceeds were used to purchase more stock in Jennings' still-growing steel cement forms business. Over the years, these stocks continued to improve in value and provided an enduring financial fallback for the Wettachs. Although their investment never yielded enough money to make them well off, it was enough to give Pete the confidence and financial stability to nurture his creative spirit and to stick with his hobby as it grew into a thriving business.

By the early 1940s, Pete Wettach had developed a regular relationship as a freelance photographer and writer with several farming magazines, including *Wallaces' Farmer and*

Iowa Homestead, a nationally popular biweekly newspaper launched by the Wallace family in the late nineteenth century. The *Wallaces' Farmer* masthead credo, "Good Farming, Clear Thinking, Right Living," underscored the publication's goal to help link isolated farm families while educating them about scientific farm practices, health and safety issues, political initiatives, and national and world affairs. Henry A. Wallace, grandson of the founder and part of the third generation of Wallaces to edit the magazine, had left some years earlier to become Secretary of Agriculture in Franklin D. Roosevelt's New Deal cabinet (he would eventually serve as FDR's vice president) but his editorial style was maintained in his absence. Coincidentally, Pete Wettach also worked under Henry Wallace's influence during his day job. The FSA was part of the Department of Agriculture under Secretary Wallace, and many of its programs, including the TP program, were heavily influenced by Wallace's vision.

The biggest unanswered question about Wettach's fourteen-year career with the FSA is: What did he know, or think, of the FSA's now-famous photography project? From 1935 to 1943, while Wettach was quietly taking thousands of photographs of farms and farm people, his employer was sending out photographers to take pictures of rural scenes all over the country, including Iowa and its neighboring states. The FSA photographers, however, were specifically commissioned to document the toll of the economic and natural disasters of the 1930s in order to bolster public support for Roosevelt's New Deal relief programs, especially during the mid and late 1930s. Several of these photographers built their artistic reputations while promoting the FSA's agenda. Wettach had no such agenda to guide the target of his camera lens, but he did have a sensitivity to the experiences of his friends and neighbors. He considered their lives to be worth recording on film.

Since he was a self-employed independent photographer, Wettach's approach to taking pictures of rural people during the Depression and later years was molded by a combination of his own vision and those of the magazines and newspapers that bought his photographs. His pictures tend to emphasize resilience instead of devastation, incremental successes instead of failure, humor and warmth instead of loneliness. If the FSA's photography project helped us understand what it was like for American farmers to hit bottom, then Wettach's photographs can teach us how they climbed out of the abyss.

The subject matter of Wettach's photographs varies greatly, but it almost always concerns farm life. Despite (or maybe because of) his painful failure as a farmer, he retained a romantic enthusiasm for the intrepid farm families who stuck it out. He was not bitter, although he was undoubtedly wiser, funneling his admiration for farming into his craft as

a photographer and using that craft as a tool to describe the simple joys and harsh realities of life on the land.

At first Wettach took pictures of people he knew: family members such as the Grimes family and Ruth and Bob, local farmers, and his or his colleagues' FSA clients. His subjects were mostly from Henry County but also included many from his FSA counties and adjacent areas. Over time, especially when he was able to travel as a freelancer, the geographic range of his photos reached other corners of Iowa and later other states around the nation.

"The idea was to take photographs of subjects that I liked and then try to find a buyer," Wettach wrote later in life, and it was this mindset that produced a huge volume of photographs of men, women, children, animals, crops, and machinery, designed to document and often to celebrate farm life. Despite the realities of his photography business, however, Wettach never completely left behind his artist's sensibilities when taking pictures. His striking photographs impressed people, even if they did not necessarily think of his work as art per se. Robert Wettach remembers his father expressing annoyance when someone said to him, "Gee, you must have a really nice camera!"

"That's a little like telling a painter, 'Gee, you must have a really nice paintbrush!'" Pete Wettach would complain.

Wettach set up his business to provide stock photographs, which meant that he had to develop a ready supply of images on a variety of subjects to offer to publications as they needed them. He organized his enormous collection of negatives by subject rather than by date or location, marking hundreds of film boxes with labels such as "SHEEP," "THRESHING," "FARM WIVES," "BUILDINGS — POOR," "HANDY IDEAS," "RYE, OATS, WHEAT," and "DAIRY." A single box could contain more than a hundred negatives taken over a period of twenty, twenty-five, or even thirty years.

The handy ideas motif in particular would turn into a major focus for Wettach. Recognizing that farmers were inveterate innovators and tinkerers and that farm magazines were eager to promote this enthusiasm, Wettach set out in search of homemade inventions to photograph. "What have you got that's new or handy?" one farmer remembers being asked by Pete Wettach, who wouldn't take "not much" for an answer. He would poke around and eventually find a few things, stopping while he was there to take a picture of a barefoot child feeding geese or a striking vista of the rolling farm countryside.

Wettach often provided a suggested caption or background information for prints that he hoped to sell. In the earlier years, he would write in pen or pencil on the back of his prints. Later, he would type what were often lengthy captions onto paper, then cut and

paste or tape the slips to the backs of the prints. These captions, indicated by quotation marks throughout the photo sections of this book, would typically name the people and the location pictured, but seldom a date, unless he was peddling one of his older photographs for sale as a nostalgic item.

Browsing through copies of *Wallaces' Farmer* from the late 1930s, the 1940s, and into the 1950s is a bit like looking through a catalog of Pete Wettach's work. The use of his pictures in this publication was routine, with photos sometimes appearing in nearly every issue for several consecutive months. Some photos were decorative and unrelated to the text, such as a photo in a winter issue of a horse pulling a sleigh, while others illustrated themes presented in articles. A photo of a boy on his pony, for example, was used at least twice by *Wallaces' Farmer*, once as part of a photo essay on children and ponies, accompanied by readers' letters, and once as a stand-alone photo with a caption about using a pony to do errands.

In 1949, Wettach decided to leave government work for good and strike out as a full-time freelance photographer. The FSA had by then become the Farmers Home Administration, and its mission had evolved through the Depression and World War II as the economic conditions improved for farmers during the war and postwar years. He began to travel more widely, often with Ruth, and he also began to take some of his pictures in color. With more time to spend exclusively on photography, Wettach took many more pictures than he had before. His subject matter became more technical than it had been, in response to farm publications' interest in keeping up with the latest scientific and technological developments in agriculture, but he never lost his artist's eye. Even later in life, he took compositionally striking black-and-white photographs, some of which are included in this book.

In 1959 Robert Wettach, by then a young doctor, built a clinic in Mount Pleasant with an office and darkroom in the basement for his father. Pete Wettach would work out of this space at 204 North Main Street for the next sixteen years. In 1975, while working in this darkroom, he had a stroke that incapacitated him. He died a year later, on May 31, 1976.

Over the course of his career, Pete Wettach sold his photographs to many publications, especially those catering to farming audiences. These included agricultural magazines such as *Country Gentleman*, *Farm and Home*, *Capper's Farmer*, *Popular Mechanics*, *Successful Farming*, *Prairie Farmer*, *Farm Journal*, *Nebraska Farmer*, *American Agriculturalist*, and *Progressive Farmer*; general-interest publications such as *National Geographic*, *Saturday Evening Post*, *Look*, *Reader's Digest*, *U.S. News & World Report*, and *World Book*

Encyclopedia; and newspapers, including the *Des Moines Register*, the *St. Louis Globe-Democrat*, and some local Iowa papers.

The photographs in this book barely scratch the surface of Pete Wettach's life work. Only his black-and-white photographs are presented here and, of those, most were taken before 1960. As of this writing, many of Wettach's negatives have not yet been archived by the State Historical Society of Iowa and are still in his original boxes, unseen for decades. Even within these limitations, however, there were thousands of images to choose from. The following are offered as an introduction to an enormous and still largely unexplored collection.

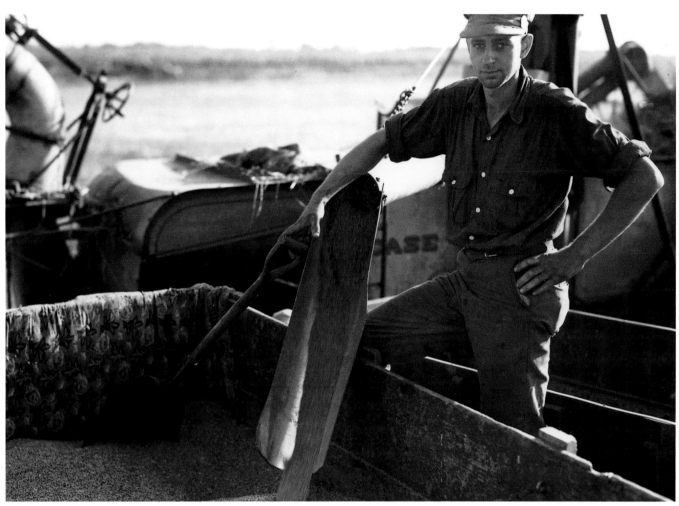

*Threshing oats, probably mid 1930s. An old quilt thrown over the
back of the wagon keeps the grain from falling through the cracks.*

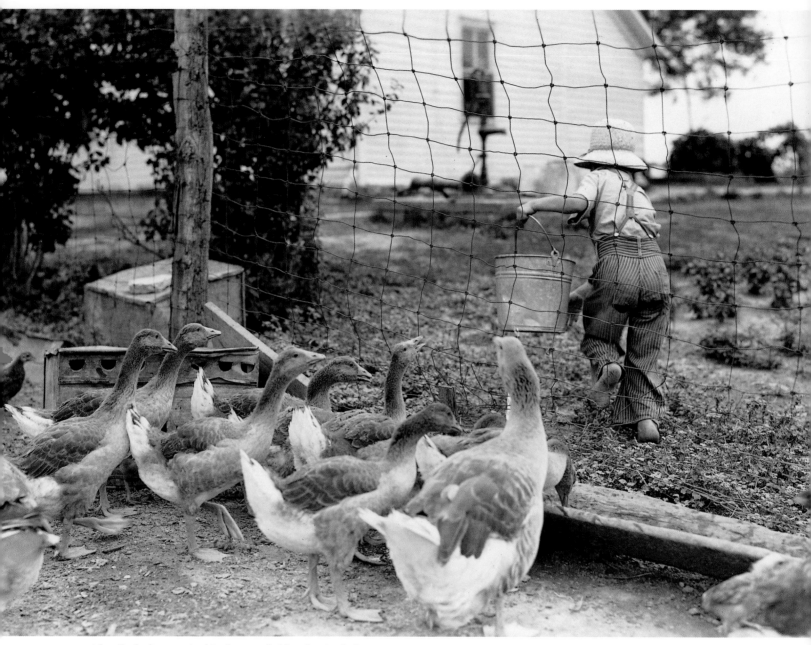

A boy feeds the geese in this photo probably taken in the late 1930s.

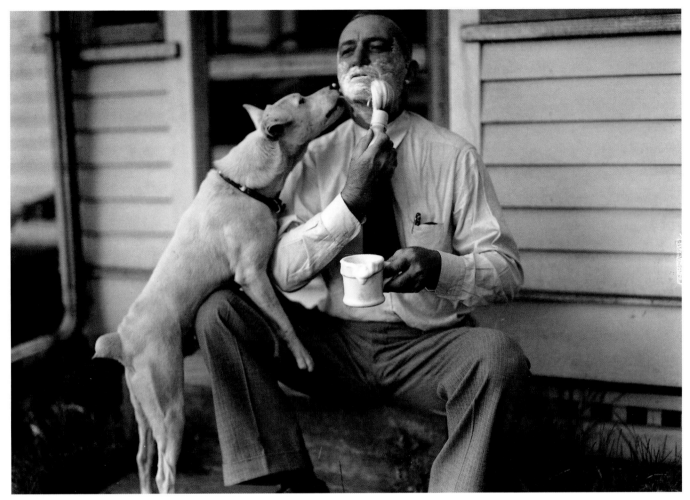

A man and his dog in an unexpected pose.

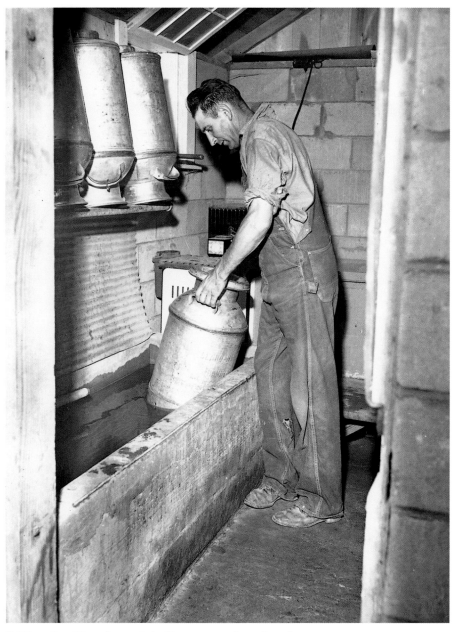

"Milk cooling. Water from windmill pump runs through tank on way to outside stock tank. 1951. Ernest Fox, Keokuk, Lee Co., Iowa."

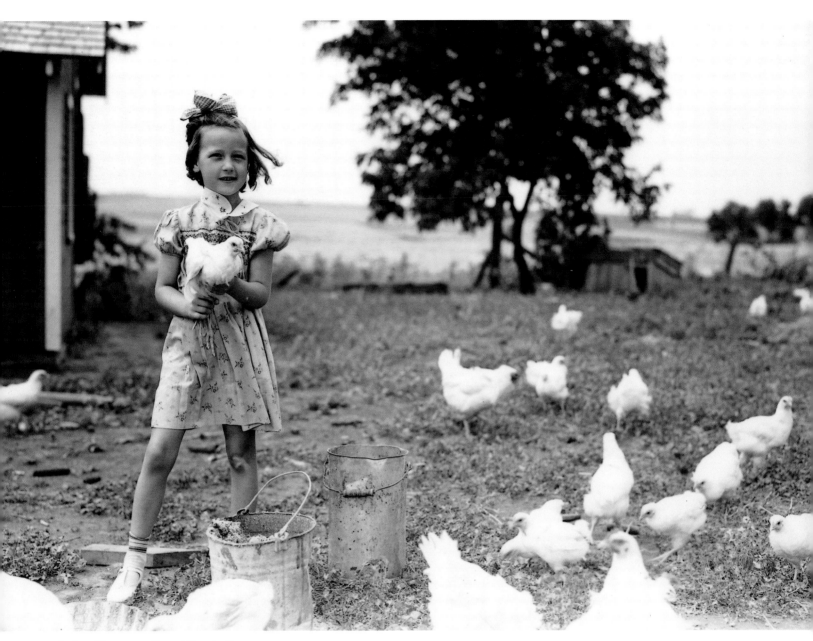

Audrey Magnuson, Emmet County, Iowa, 1940.

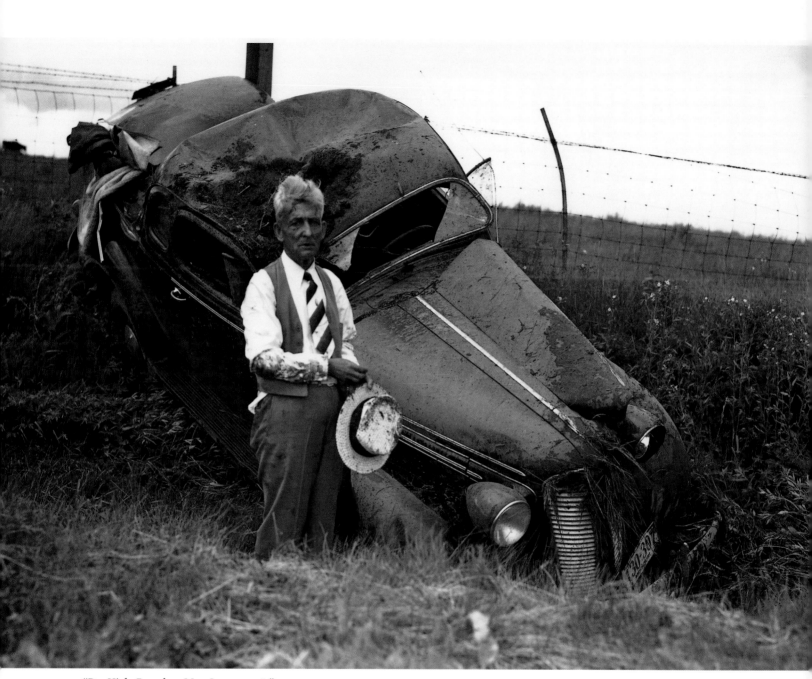

"Dee High, Brandon, Mo., June 1, 1938."

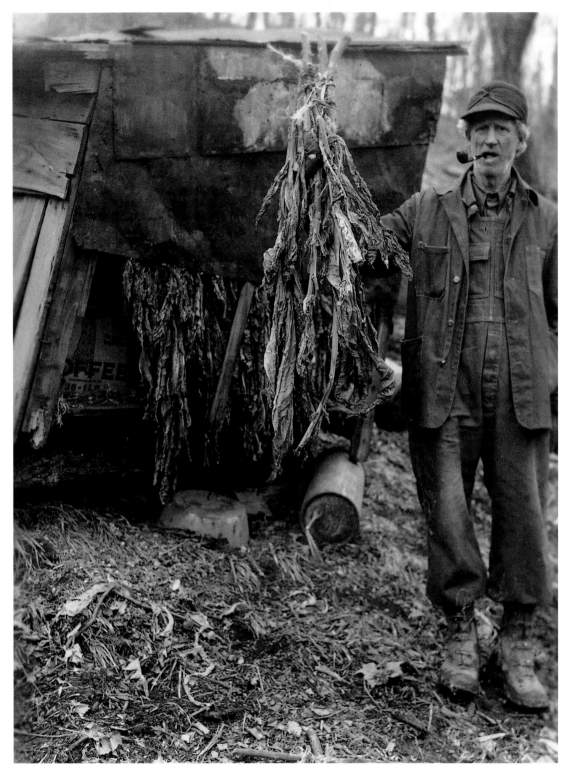

A man holds up a bunch of tobacco in this Depression-era photo taken on the river bottom near Columbus Junction, Louisa County, Iowa.

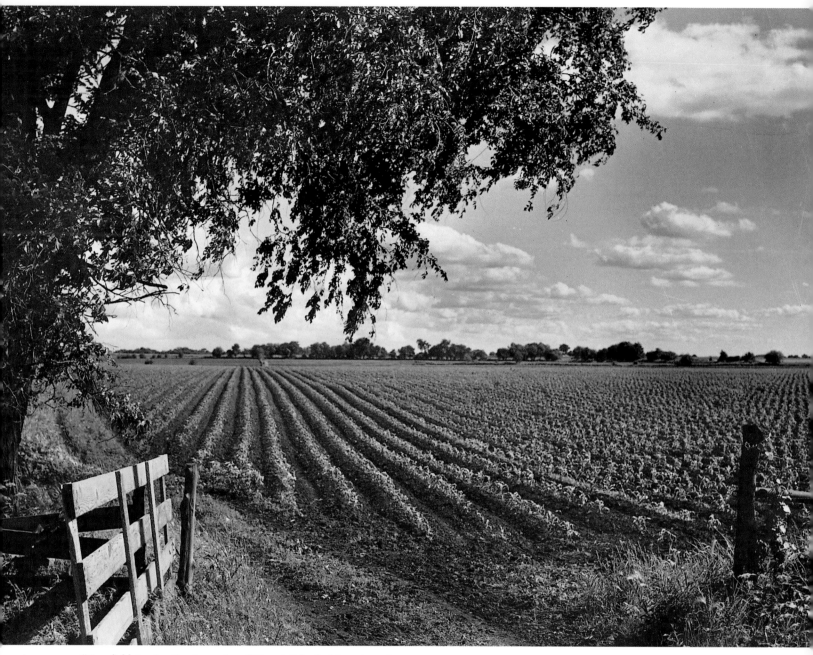

"Cornfield, Louisa Co., Iowa. June." Corn is *"checked,"* or planted
in evenly spaced rows, probably by a horse-drawn planter.

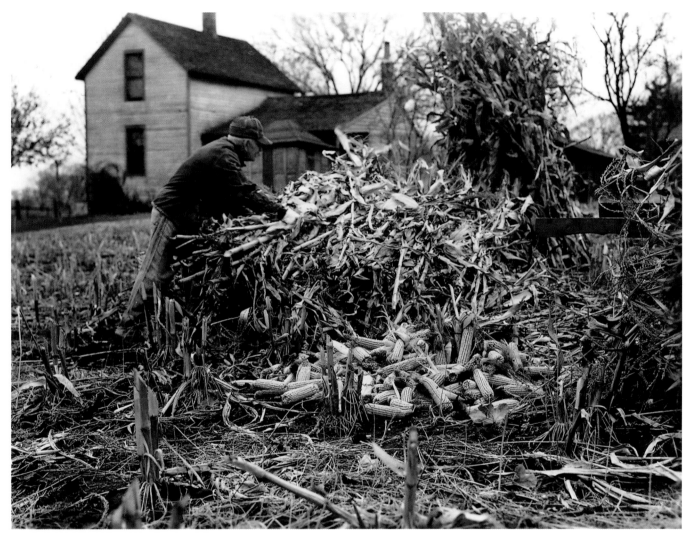

"Shucking out of the shock. Henry Co., Iowa."

Three children in front of a farmstead.

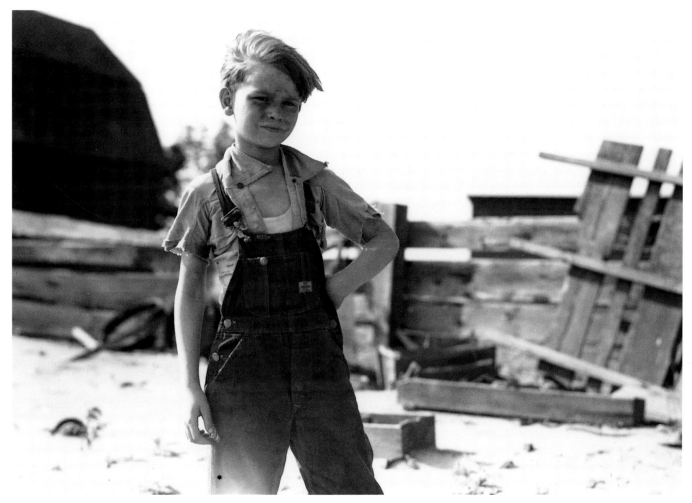

A young boy standing in a barnyard.

Close-up of wheat.

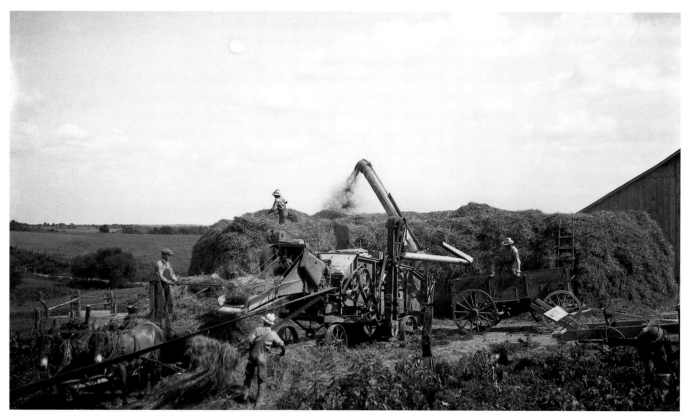

Threshing crew near Montrose, Iowa, 1925.

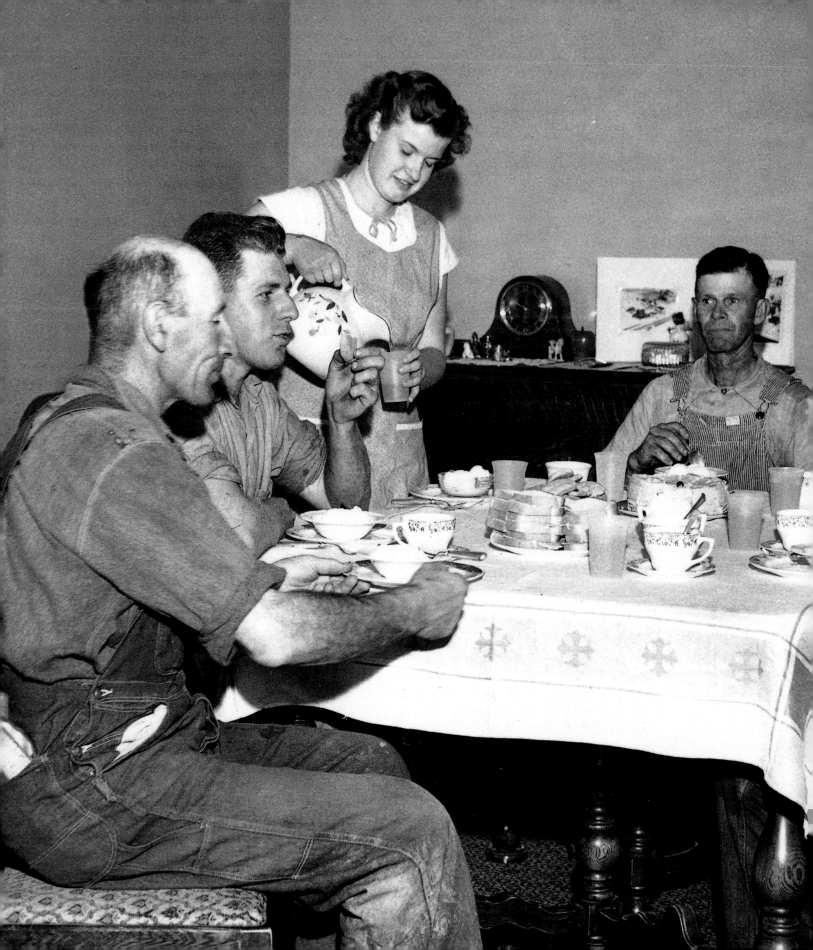

Partners on the Land

Pete Wettach knew how critical women were to the success of the family farm. When visiting his Farm Security Administration clients, he often traveled with a home economist and together they would meet with women who ran their farm's household. In a time when little cash was available and when farm families produced much of their own food and other staples, women's skills could easily make or break the entire farming operation. Wettach clearly took as much of an interest in these activities as any other, despite the generalized division of farm work along gender lines. Many of his photographs underscore the complementary responsibilities of women and men needed to sustain this partnership.

The realm of the farm woman was the household, but her work did not end there. Indoors, women typically took responsibility for every domestic activity, including cooking, cleaning, processing and preserving food, child care, sewing, and laundry. Outdoors, women managed many aspects of the barnyard, including the daily feeding and tending of poultry, dairy, and other livestock (although men were more likely to perform the heavier work with the larger animals) and the family garden. Depending on their age and ability, children were assigned to help their mothers or their fathers, with the younger children of both sexes usually staying close to their mothers. Older children were more

Marriage meant more than companionship and child-rearing: it was a lifelong joint business venture. To exist, the farm needed the contributions of both women and men. Yet, only in recent times have these farm women been recognized as contributing, economic partners.

Margaret Atherton Bonney,
Women: Partners on
the Land

likely to work with their same-sex parent, although this varied depending on the number of sons and daughters, whether the farm had any hired hands, and what help was most urgently needed. It was not uncommon for women to assist their husbands, fathers, and sons with field work as needed, occasionally operating large machinery and doing so with as much skill as any farm hand.

Women often took charge of keeping the farm's financial records, carefully tracking the income and costs associated with the business of farming in the face of fluctuating markets and weather conditions. Many women generated a fair income from the sale of eggs, chickens, and cream, income often viewed as "egg money" or "pin money" to do with as they pleased.

Women contributed to the effort to make do in each farm household during the Depression and later years. They were often as flexible and innovative as the men at reusing, extending, and adapting. Mabyn Jensen Fox, who grew up in Clinton County, Iowa, remembers that her mother, Marjorie Jensen, made aprons, pajamas, and other clothing out of chicken feed sacks. This was a common strategy for saving on clothing costs (although Mabyn is quick to point out that the apron her mother is wearing in the picture shown in this chapter was one of her "good" ones, put on for the benefit of the photographer). The sacks came in a variety of prints in a cotton material that was soft but sturdy enough for everyday use. Mabyn looked forward to the arrival of the feed sacks, hoping for a few sacks in one of her favorite patterns, so that she might have enough material for a larger garment.

Changing technology on the farm affected the women's realm as well. Probably the best example of this is rural electrification, which revolutionized the farm household as all members reaped its benefits. Electricity provided better lighting for chores done before dawn and after dark, as well as for evening recreational activities such as reading, needlework, or board games. With electricity (and some extra spending money), women now had access to a number of labor-reducing appliances that made a substantial impact on their daily work loads. Although some mechanized appliances could be run without electricity — earlier clothes washing machines, for example, could be operated by hand or with a gas-powered motor — many farm women sought the flexibility and cleanliness of electric power for refrigerators, stoves, and washing machines. Other, smaller electric devices such as toasters, coffee pots, mixers, clocks, and radios also became popular as their availability boomed after World War II.

Traditional views of the Iowa farm wife can be seen in Wettach's photographs: the one who scrimped and made do during the Depression; the one who desperately missed her husband or sons during World War II, while doing the farm work or taking a job in town

to make ends meet; the one who welcomed the postwar parade of modern amenities, such as electricity, running water, and labor-saving appliances; and the one who sewed, canned, raised chickens, and cooked the threshers' dinner. All of these women certainly existed. But Wettach's photographs show us that they also led lives that were complex and often surprising, defying what we might expect of them and offering the curious viewer as many questions as answers.

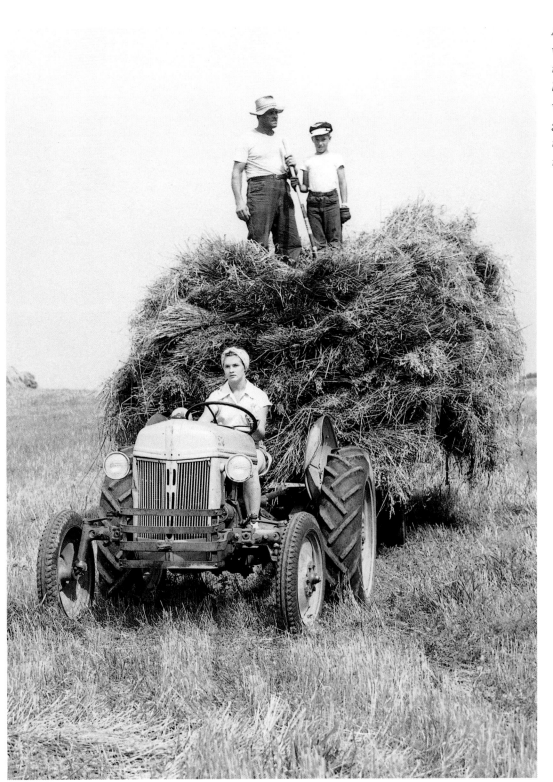

A young woman, a man, and a boy bring a wagonload of grain to the threshing machine.

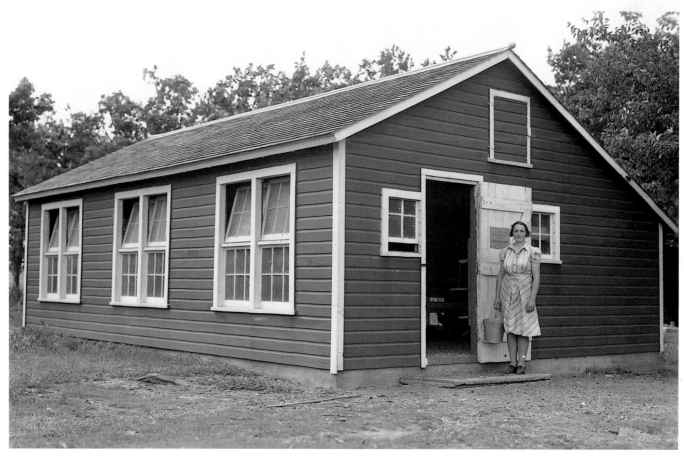

"It takes a good house to take the best care of chickens, Mrs. Shonkweiler, Emmet Co., Iowa."

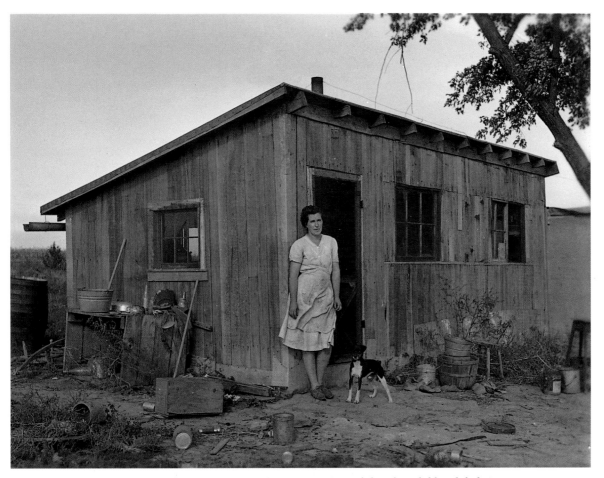

Emma Jorgensen and the family dog, Jack. Emma and J. C. Jorgensen and their four children left their Nebraska farm after a drought, arriving near Mount Zion in Van Buren County, Iowa, around 1941. The farm home of the previous owners had been destroyed by fire, so the Jorgensens converted and moved into this poultry house. They attached a trailer they had pulled behind the car from Nebraska, making it into a bedroom for their three daughters. The barrel shown here was used to collect rainwater for washing and other purposes. A neighbor shared drinking water with the family, as well as the use of a gas-powered clothes washing machine. The Jorgensens returned to Nebraska in the mid 1940s. A photo of the Jorgensen children, taken on the same day, is in chapter 4.

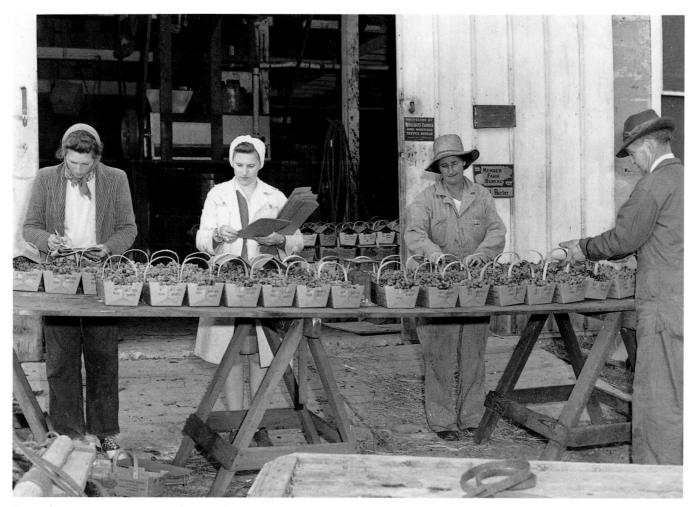

"Grape harvest at Baxter's Vineyard, Ft. Madison, Lee Co., Iowa. Left to rt, Mrs. Robert Griswold — tallying; Rosie Beach — 'Lidding'; Mrs. Frank Schmoldt and Lee Holt unloading cart. 1945." Women occasionally earned income by working outside their homes and farms, especially during World War II when jobs that were usually performed by young men were available to them. Here three women and a man provide extra labor during the grape harvest.

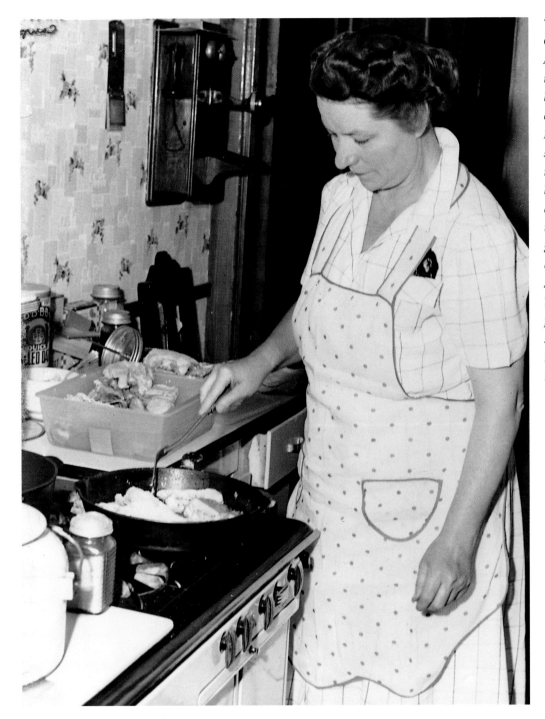

"Mrs. Venus Jensen, Clinton County, Iowa, has a new stove. A good stove lightens the work in the kitchen, especially in the hot weather. Here she is frying chicken for a Sunday dinner." Marjorie Jensen's new stove, shown here in 1946, was a novelty; few appliances could be purchased during the war, and many women were forced to improvise when old stoves gave out. The article that accompanied her photo in the July 20, 1946, Wallaces' Farmer *cited a publication poll of farm women in which 43 percent expressed plans to buy new stoves as soon as they became available.*

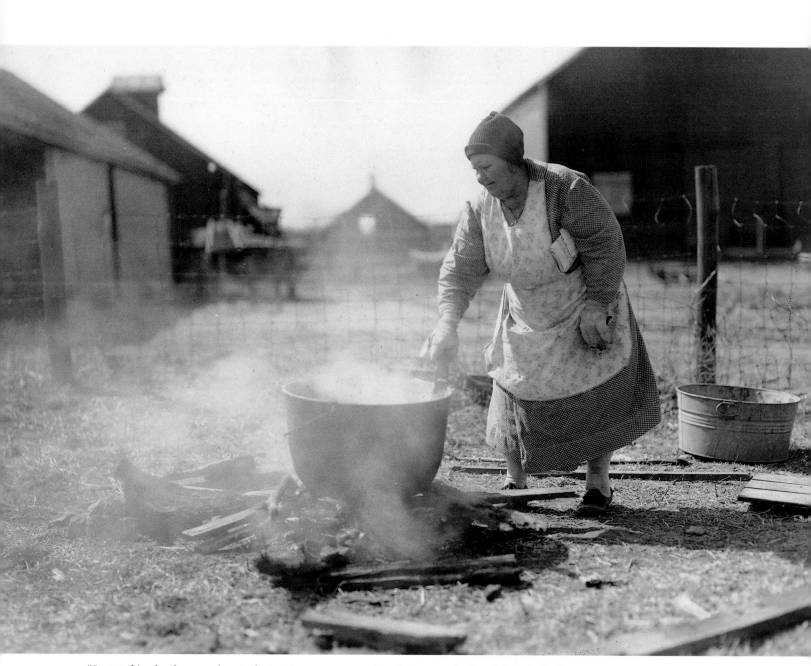

"Soapmaking has become almost a lost art in many communities, but not on the Newell farm in Louisa County, Iowa." Even in the depths of the Depression, farm women usually bought soap rather than making it themselves. The Des Moines Sunday Register *paid Wettach $5 for this photo, taken in 1937, which ran in a "Vanishing Iowa" section of the January 16, 1938, paper.*

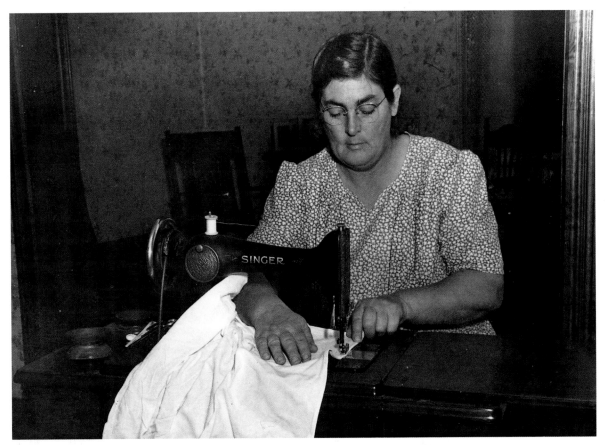

"Mrs. Keller does a great deal of sewing — more before the children were grown than now." Late 1940s.

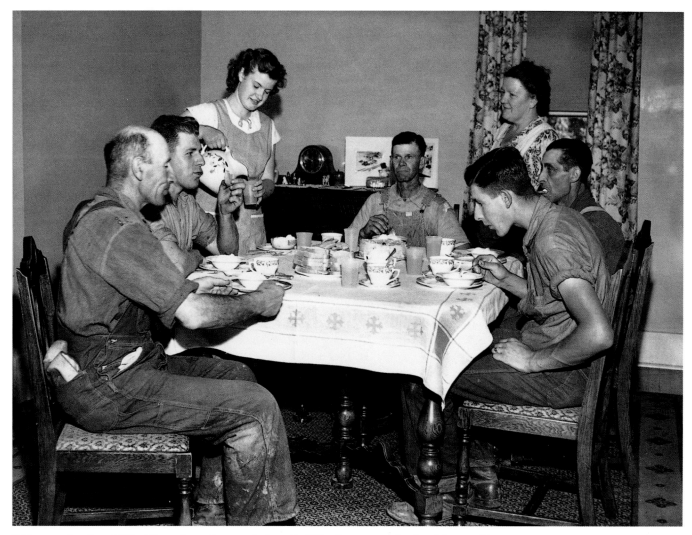

"Afternoon lunch — Clifford Grant farm, Preston, Jackson Co." The Grants owned a threshing machine, and the other men were from some of the fifteen to twenty farm families that participated in the threshing ring. These rings sometimes became their own little communities, fostering close social ties. Verana Grant Johnson (standing, left), a teenager in the late 1940s when this picture was taken, considered Hugo Theilen (far left) to be a "second father." The young man on the far right, Loren Nolting, eventually married Verana's sister. Members of threshing rings regularly helped each other with other tasks. On this day, the group had helped tear down a shed.

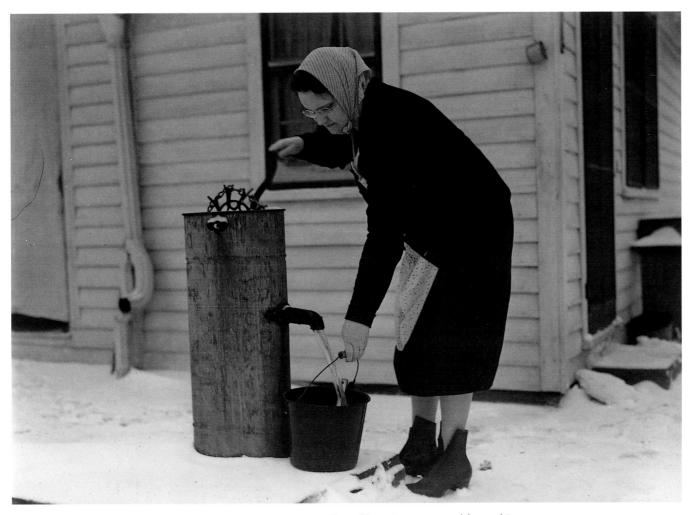

Ruth Wettach fills a bucket with water from a cistern. Rainwater collected in a cistern was used for washing or bathing but not for drinking. Before farms had indoor plumbing, a water pump, providing either collected rainwater from a cistern or well water, would generally be located close to the house for convenience. Women (or children big enough to carry the loads) usually brought the water supply into the house as needed. Probably taken in the late 1930s.

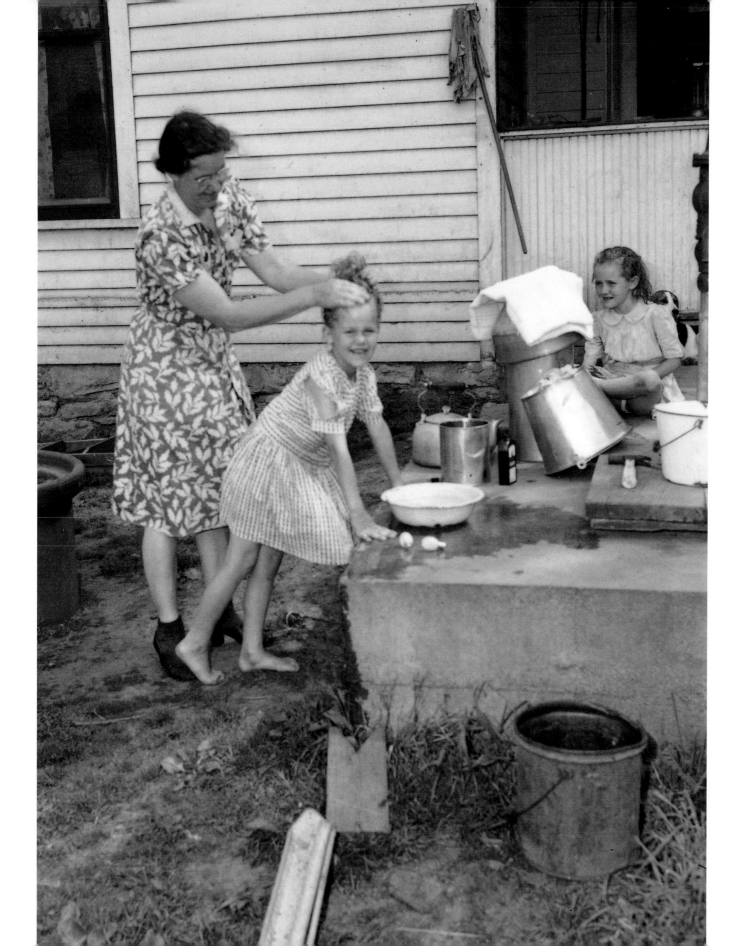

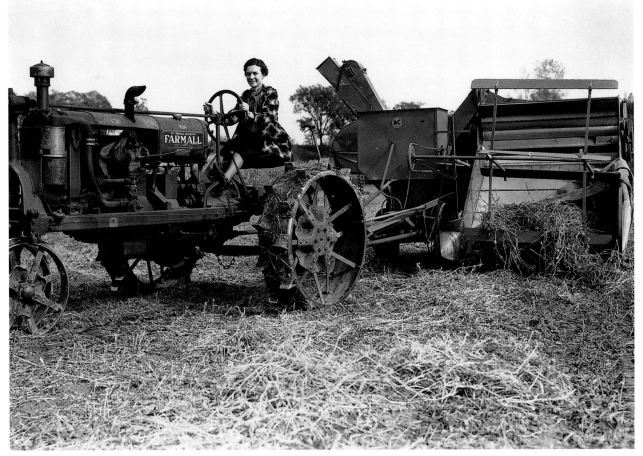

Even though she is hamming it up for the camera in clothing that looks a bit too dressy for field work, this woman was probably very adept at driving this Farmall tractor. Although a lot of farm labor was divided along gender lines, most farm women would occasionally lend a hand with work usually done by men.

A mother washes her daughter's hair using water from a cistern. Taken around 1944.

"Mrs. Clarence Unkrich, Winfield, Henry Co. Julia (3) helps her mother. The all-electric kitchen frees Mrs. Unkrich for helping put in and harvest crops which she likes very much to do — and is an expert with the tractors and other machinery." Rural electrification provided an opportunity for farm families to modernize their households. Here we see a scene from a 1950s farm kitchen which has a dishwasher, an electric mixer, and a coffeepot in one corner of a kitchen that probably also has a refrigerator and other electric appliances. The labor-saving devices that electrification offered to farm women were often promoted as a way to free them from one kind of work so they could do another — in this case, help during planting and harvest. Photo printed courtesy of Reiman Publications.

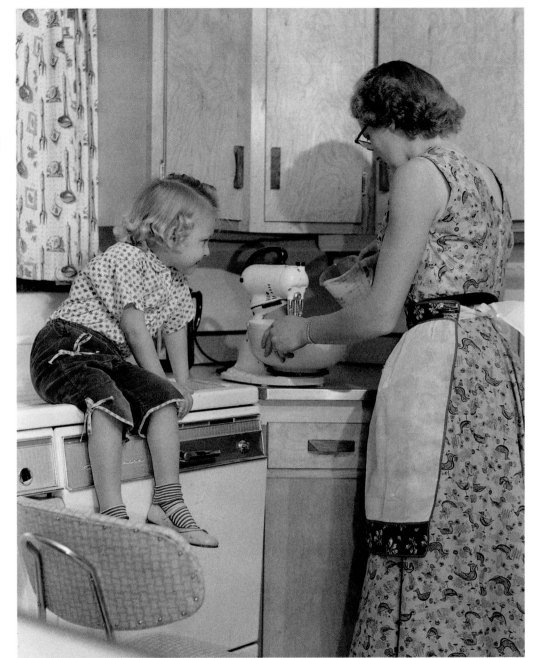

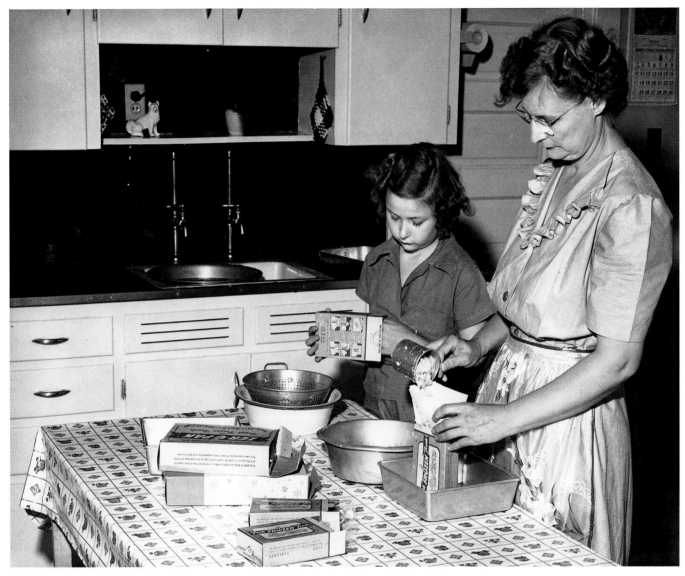

"Preparing sweet corn for freezing in locker & deep freeze." Although this household had electricity (note the outlet above the sink), it probably had a refrigerator typical of this period, with a tiny freezer compartment. Some families rented space in a community freezer, or locker, to store garden produce and meat for their own use throughout the year. Some lockers even provided butchering services. In this photo, probably taken in the late 1940s, a woman and a girl pack sweet corn from the garden into boxes to take to their rented locker in town. Photo printed courtesy of Reiman Publications.

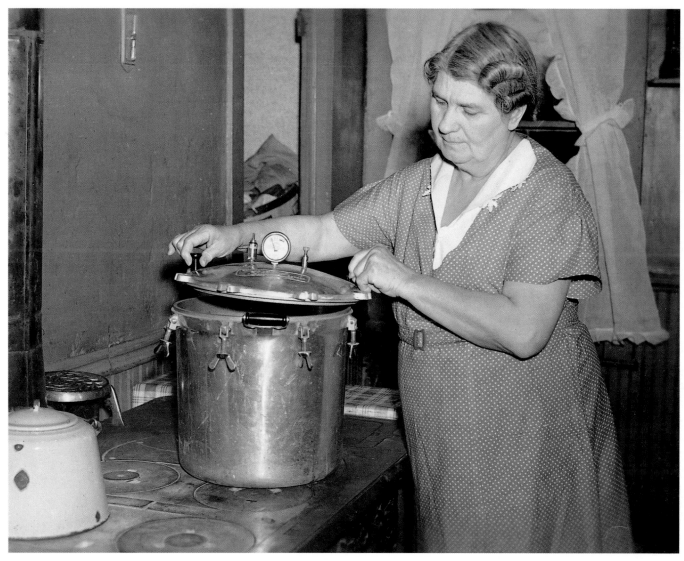

A woman demonstrates the use of a pressure cooker for canning. The canning of produce and meats raised on the farm helped families be more self-sufficient during tough economic times. In fact, a pressure cooker was one of the few mandatory pieces of equipment for farms in the Tenant Purchase program. Women in the program who did not have one received a fifteen-dollar grant for its purchase.

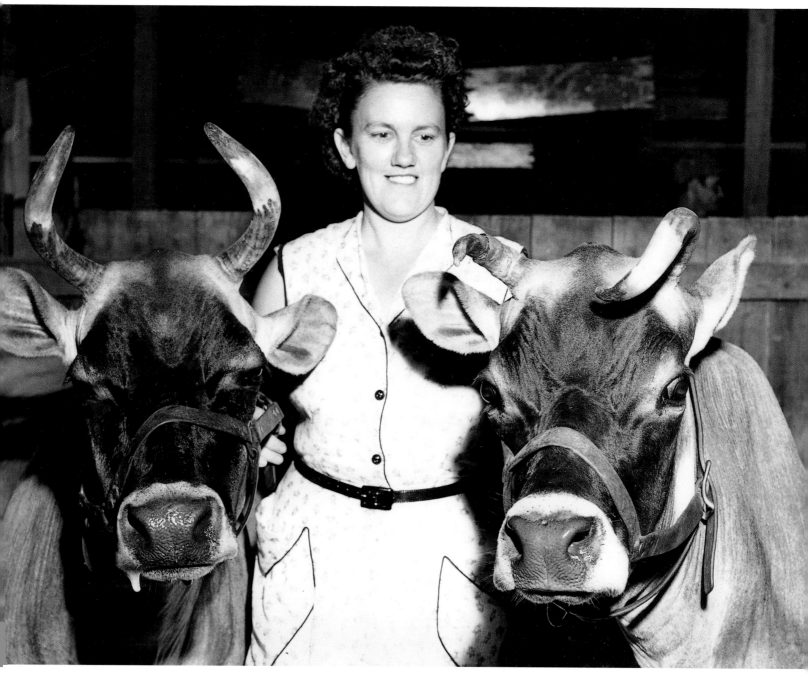

"Among the exhibitors at the Lee County Fair at Donnelson are the R. M. Hudsons of Wayland, Missouri. Mrs. Hudson poses a pair of their fine Jersey cows."

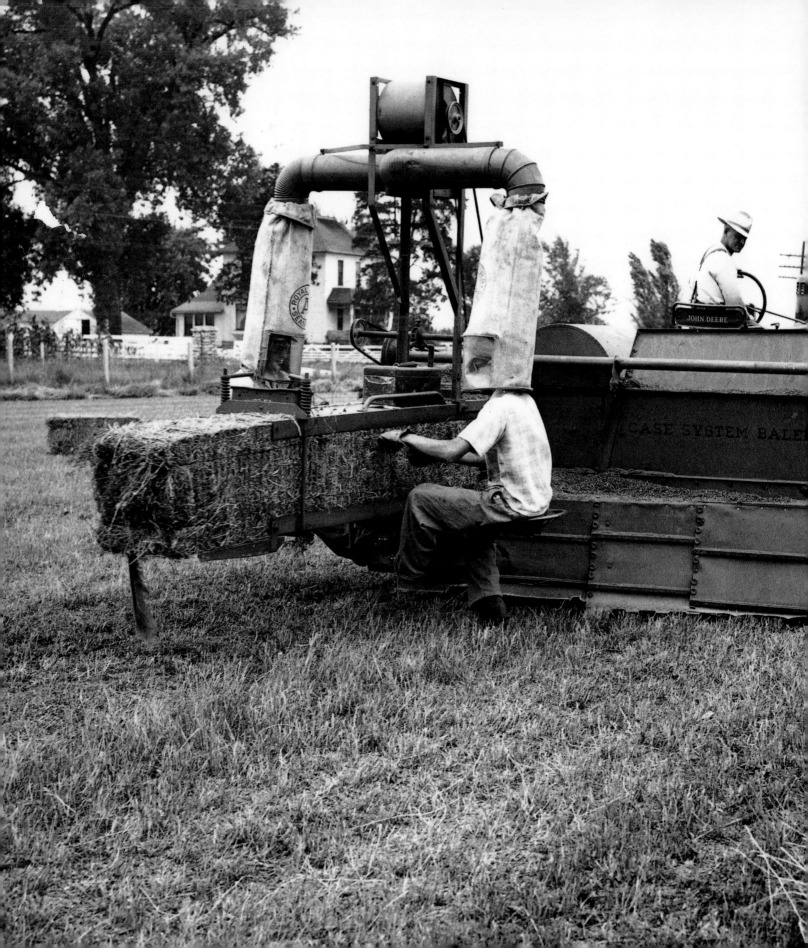

Handy Ideas

Wettach's handy ideas pictures were the bread and butter of his photography business. Recognizing that farmers were relentless adapters and inventors, he was always looking for opportunities to photograph the creative adjustments they made to equipment, buildings, farm homes, vehicles, implements, fences, mailboxes, kitchens, and more. Almost every facet of farm life was a potential target of tinkering. If there was a better way to do it, the innovative farmer was bound to find it.

By the 1920s midwestern farming had moved well beyond the nineteenth-century pioneer era. The once-pristine prairie was completely submerged under thousands of long-settled farmsteads that were passed from one generation to the next. Farming methods had also changed dramatically over the years. Every generation of farmers faced opportunities and pitfalls offered by advances in agricultural technology and scientific methods. These rapid changes forced farmers to be creative.

By the time Pete and Ruth Wettach began farming with her parents on the eve of the Great Depression in 1929, cars and telephones were common on Iowa farms, but electricity and indoor plumbing were not. Tractors had been appearing on more and more farms by then, especially in the wheat-growing areas, but fewer than 30 percent of farms had a tractor by the time the stock market crashed that year. Those that did not were unlikely

It is not enough for the modern farm to be equipped with the best tools and machinery that shops and factories turn out, to know how to use them and keep them in repair. There are many handy devices, not made in any factory and not sold in any store, that every intelligent man can make himself, which save money and labor and time.

Rolfe Cobleigh, Handy Farm Devices and How to Make Them

to acquire one until economic conditions improved more than a decade later. Instead, horses and mules, many bred for superior size and strength, powered most field equipment, including plows, planters, cultivators, and wagons. The farm family, neighbors, and hired hands provided the rest of the labor.

Not surprisingly, farming under these conditions was grueling, tedious, backbreaking work. Farmers were under constant pressure to maximize production. Technological improvements made particular tasks easier but also added to the pressure to keep up with neighboring farmers who were using the latest methods.

Ironically, the Depression may have provided a boost to farmers' innovations. Although the concept of making do predated the 1930s, severe economic conditions forced farmers to take a step back toward greater self-sufficiency or to at least rely less on store-bought goods when cash was unavailable. As the Depression marched on year after year, equipment inevitably broke down, forcing farmers to become more skilled at making their own repairs and adaptations. Junked and obsolete machinery often provided a ready source of parts and materials.

Another challenge for farmers' creative skills came along with the gasoline engine tractor as a replacement for horsepower. Once its design caught up with the needs of midwestern farmers, the tractor's popularity exploded, particularly in Iowa. However, farmers quickly discovered that their implements (plows, harrows, planters, etc.), originally engineered to be pulled by horses, could not simply be attached to the back of a tractor or hauled out to the field to plow or plant without substantial modifications. Most horse-drawn implements were designed to accommodate a driver sitting on or just behind the equipment while driving a team in front, so that the machinery could be adjusted while moving. In contrast, on a tractor seat the driver was often unable to watch or adjust the implement moving along behind.

Even farmers who were prepared to pay for new implements compatible with their tractors often found them unavailable, and so they were forced to find a way to use their old equipment. Depending on the implement, adaptation from horsepower to tractor power could require a tremendous amount of ingenuity and patience. Wettach took many pictures of successfully modified horse-drawn equipment and sold these photos to magazines whose readers were eager to find ways to make their own new tractors work.

With the onset of World War II the economy improved, but a different set of pressures came to bear: available hands on the farm decreased dramatically as young men left for the war, and products that had previously been available (though often financially out of reach) were rationed. Now farm families struggled with little or no access to goods rang-

ing from sugar and household appliances to gasoline and farm machinery. Once again, they had to improvise.

This culture of tinkering remained part of midwestern farming even after the Depression subsided and the war ended. Farmers with particularly inventive skills expanded their creations from the necessary to the convenient, the recreational, and the decorative. Even during the Depression, Wettach's handy ideas photos did not always revolve around the most necessary items. His work with the FSA often brought him into his clients' homes, where he found and photographed the many ways they had found to make their lives a bit more comfortable, from small electric butter churners to triple-decker bunk beds for the children. In later years, into the 1950s and 1960s, he took dozens of pictures of unusual mailboxes, farmstead entrances, farm fences and gates, indoor shelves, toys, and more, all mostly or entirely homemade and many unique in design and function.

It's hard to pinpoint exactly when the tinkering associated with making do turned into a source of pride for many farmers. The long-held rural belief in the virtue of thrift remained entrenched even when farm families had a bit more spending money. Farmers might spend all day trying to solve a problem by themselves rather than drive into town to buy the fifteen-cent solution. But it went further than that. Compared with their city-dwelling cousins, who depended upon and enjoyed easy access to a network of goods and services, farmers needed to function more independently. They needed to assert to themselves and to others that they could do it alone if necessary. Even if the problem at hand had nothing to do with life-or-death issues (like a handy dinner bell, for example, or a gate that would clear the snow, or a bug trap), the can-do mentality among farmers was something that distinguished them from city folks.

Farming magazine editors recognized the broad enthusiasm for handy ideas from the necessary to the nifty and routinely published articles and columns on the subject. Wettach found that these pictures sold very well, and he seemed to enjoy looking for farm gadgets and other new ideas to be photographed. He also seemed to relish giving individual farmers a bit of publicity for their small successes.

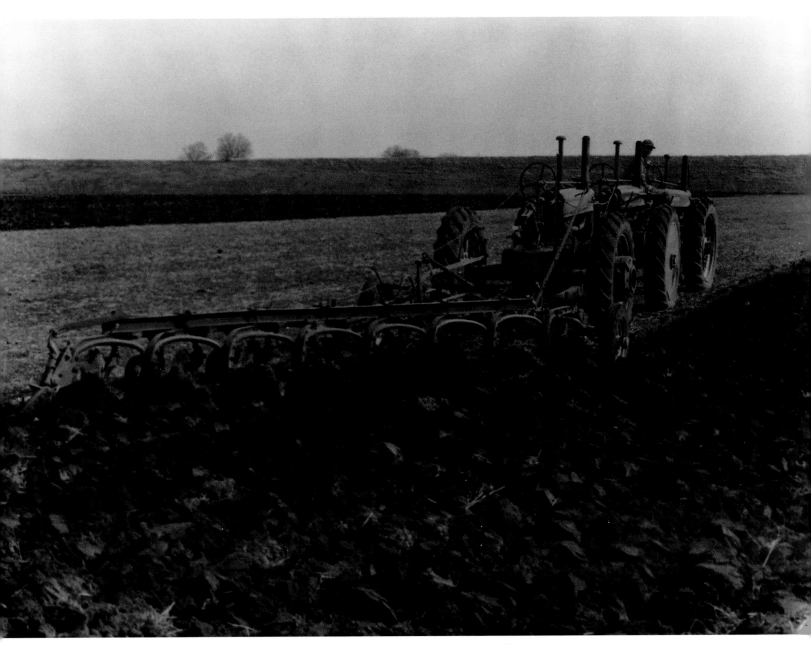

One handy idea spawns another. This eight-bottom plow, which was assembled by putting smaller plows together, is too heavy for one tractor so the farmer has devised a way to pull his new creation with the combined horsepower of three old Model A John Deere tractors. Probably taken in the 1950s.

"Bugs attracted to the light are sucked into stocking hung below the fan and are trapped. A small cage-type blower, operated by a 1/10 H.P. motor or such; the kind used on forced draft furnaces is used. The blower is hung by a light spring from the hook bent in a rod and the electric cord plugged into an outside receptacle. Roy C. Sable, Jefferson County, Iowa." This bug trap photo was taken around 1965. Wettach sold it for $7.50 to Progressive Farmer magazine.

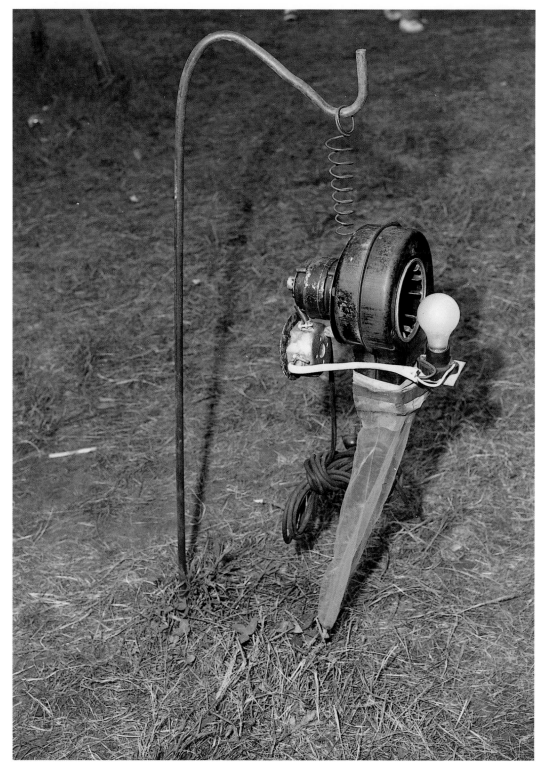

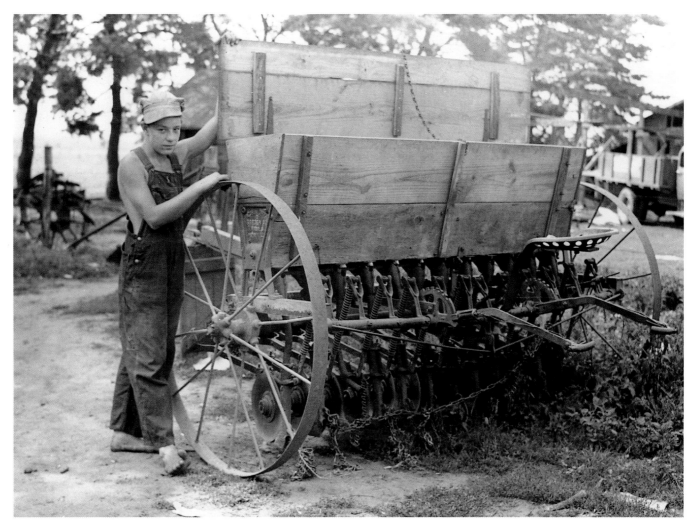

"Enlarging the grain drill by side boards and a wider lid makes it unnecessary to stop so frequently for filling." This was once a horse-drawn implement — note the metal seat on the back — but it has been adapted to be pulled by a tractor. The boy lifts the lid of the grain drill, which was filled with seed to be spread rather than planted in evenly spaced rows. The enlarged bin might have interfered with the view of a driver who had a team of horses pulling in front. With its conversion to a tractor hitch, however, the seat is no longer used.

"A farm convenience is a concrete platform from the well or cistern pump to the house or between the kitchen and wash house. It affords a cool place to wash or sit in hot weather, and saves many muddy tracks in the house." This appears to be a very early Wettach photo, probably taken between 1925 and 1935. The handy idea is the concrete porch connecting the water source — the pump — to the door of the home so that family members would not have to carry water over the muddy ground. The photo reveals many details about the back porches of farm homes of this period: a bench for doing the wash or other work, a clothesline, and a towel rack where just-washed hands can be dried. Some back doors would even have a mirror and razor for men wishing to shave before coming inside.

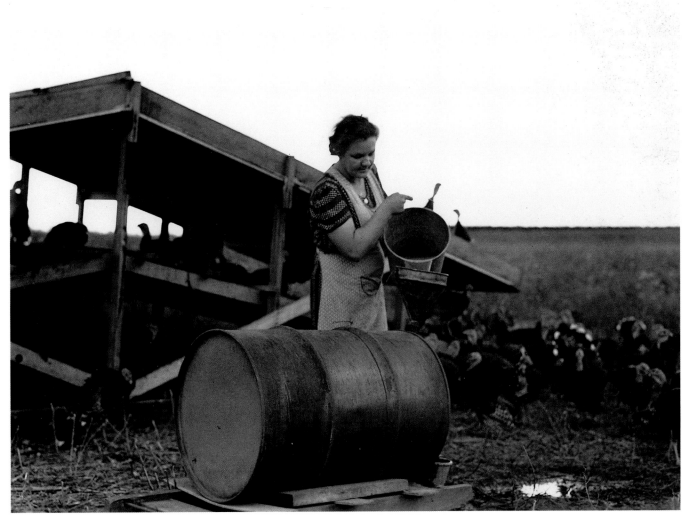

"Mrs. Wm. T. Nielsen, Emmet Co., Iowa, filling turkey water barrel. A two-cup hog waterer converts this oil barrel into a good turkey waterer. Built on skids to move on range." Taken around 1940.

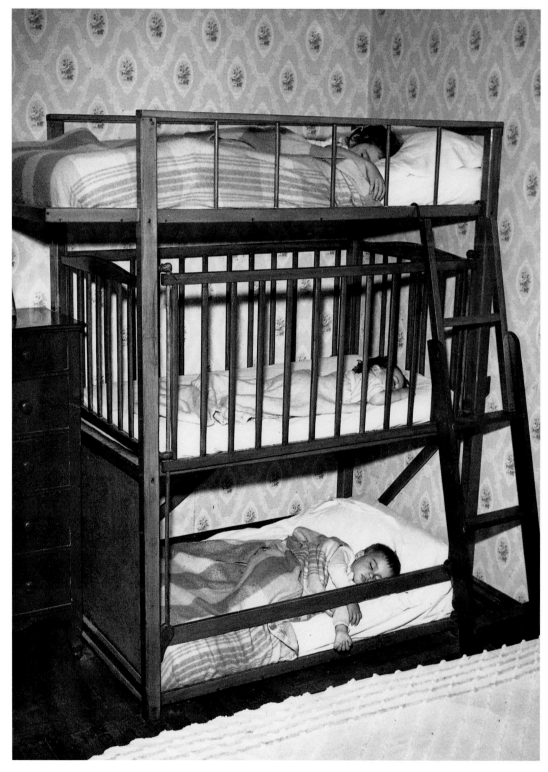

"Triple-decked bunks constructed by remodeling a double one. Side of center bunk drops to convert lower into a play pen." Wettach found handy ideas in every corner of the farm home, including this children's bedroom adapted to make space for a growing family. Photo printed courtesy of Reiman Publications.

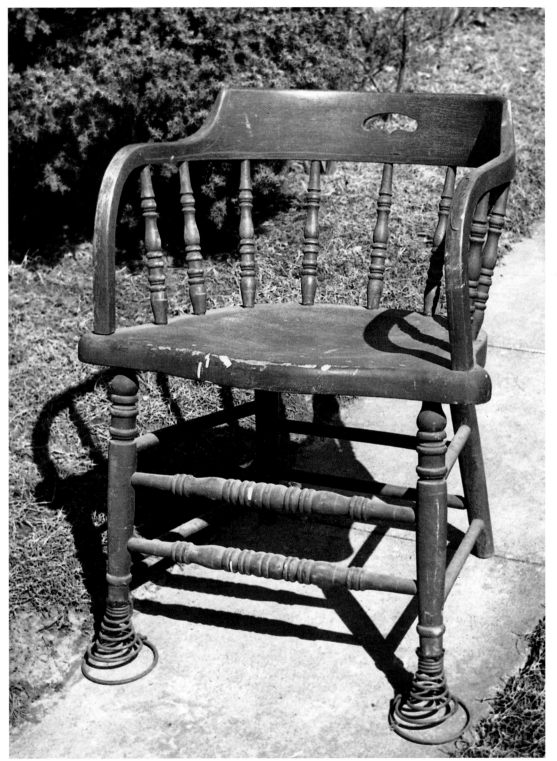

"An old easy chair made more comfortable by the addition of heavy coil springs to the front legs." Wettach was not the least bit shy about taking humorous photos.

59

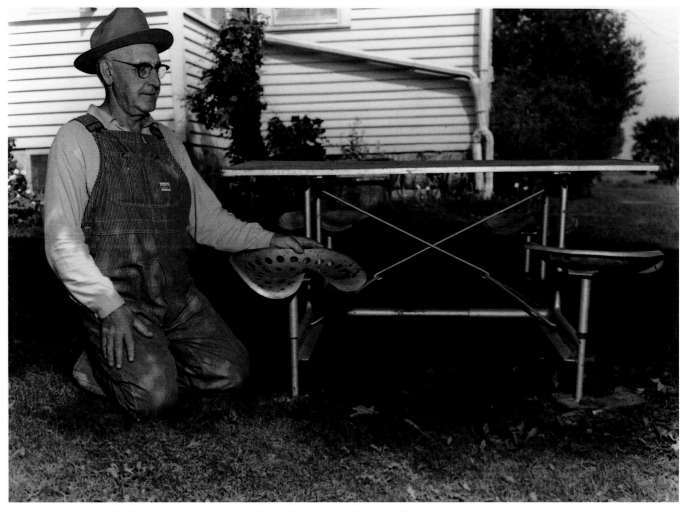

This farmer may have had his grandchildren in mind when he constructed this small picnic table using seats taken from old horse-drawn implements. Probably taken in the 1950s.

"Jack Erwin, Henry Co., Iowa feeding Hi-line pullets on range in a home-made trough-shaped feeder having a lath nailed to the top to keep birds from getting in with their feet." The thin piece of wood, or lath, going across the top of this feeder keeps the chickens from stepping into their feed, so they won't kick it onto the ground. Wettach provided a lot of detail about how this feeder was built, even drawing a picture of its components on the back of the photo. Photo printed courtesy of Reiman Publications.

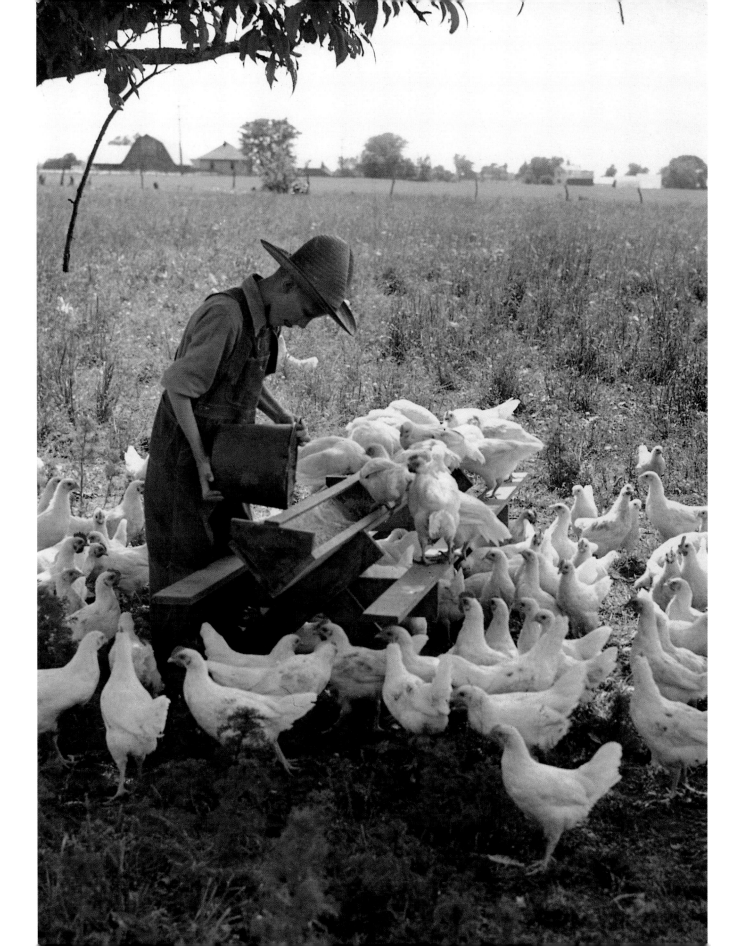

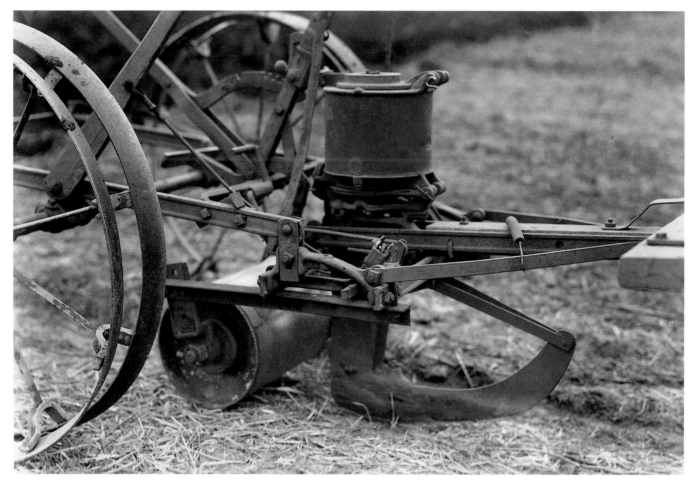

"An old horse drawn planter was converted into a melon planter by shifting one shoe and planter box assembly to the center of the frame and attaching a roller behind the shoe. The dropping was done by a hand lever working the check wire lever. Otto Jackson, Wapello, Iowa." Taken around 1940.

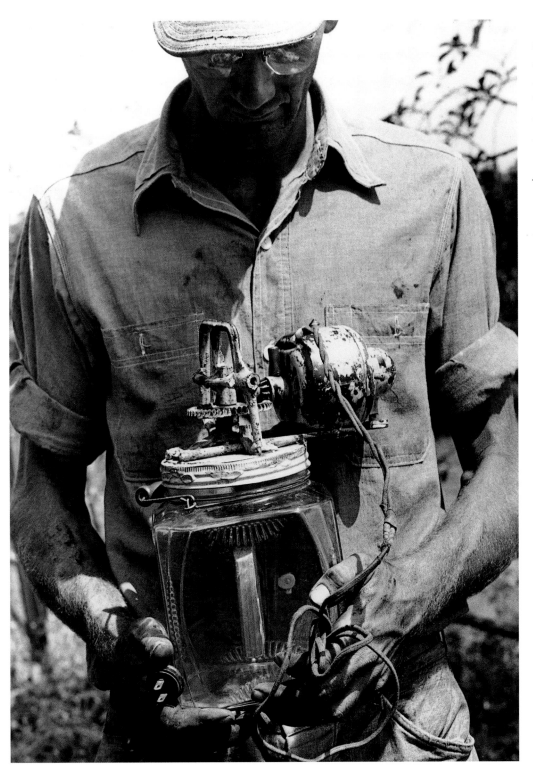

"This fan electric motor mounted on the one-gallon churn takes the work out of butter making when the butter won't come. Built by Junior Coon, #2 Morning Sun, Louisa Co., Iowa." Junior Coon, a particularly adept farmer-tinkerer, caught Wettach's attention and was the subject of a number of photos. Photo printed courtesy of Reiman Publications.

"*Donny Coon, son of Mr. & Mrs. Junior Coon, #2 Morning Sun, Ia. starts his 'racer'— built by his dad.*" Here, Donny Coon is the beneficiary of his father's tinkering. Taken in the mid 1950s.

"Baling alfalfa — Walter Hatch driving and James and Everett under the dust hoods, #5 Mt. Pleasant, Henry Co., Iowa." A furnace blower on top of the hoods forces air down on these boys' heads to keep the alfalfa dust out of their faces while they hand-tie each bale. While it wasn't usually hazardous unless the hay had become moldy, dust from these bales could be quite irritating.

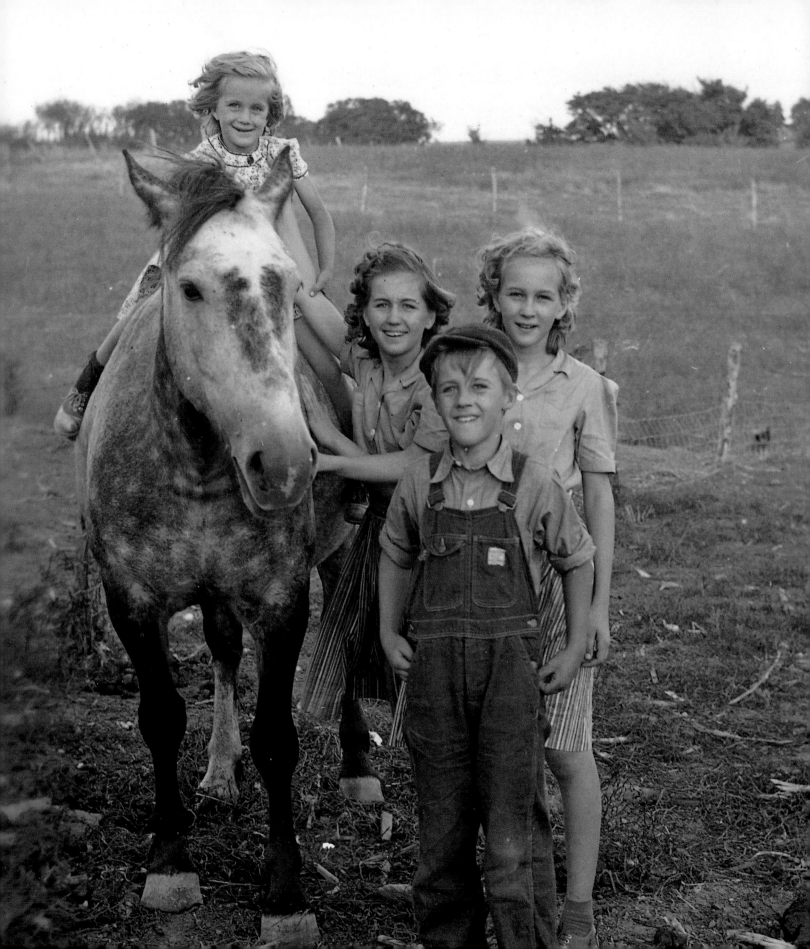

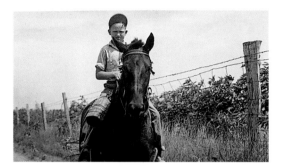

Children on the Farm

Among Wettach's most captivating images are those of farm children. By the 1930s child labor laws and changing social attitudes had largely removed younger children from most workplace settings. But the farm remained, as it does today, both a work site and a home, where children grow up and contribute to the success of the family business.

Wettach's pictures of farm children capture them in their everyday environment, going about their work or their playtime as they might regardless of whether a photographer was present. Many of these photos were clearly posed, if only for a moment, but most maintain the sense of the child's normal work or play setting. Very few are unnaturally stiff or have the out-of-context aura of a family portrait.

It is hard to know what Wettach's motives were in taking some of these pictures, but many of the publications that would buy his handy ideas photos also ran attractive shots or theme montages of children. It is also likely that he simply stumbled across many of his child subjects while looking for other material to shoot. The picture of Kenny White on his pony, for example, was taken during a shoot of White's father hulling clover. That photo ran in *Wallaces' Farmer* as part of a photo essay on boys and their ponies, accompanied by nostalgic vignettes sent in by readers, as did a picture of Kenny's father, Roy White, at work.

They say the best product off a farm is the children.
 Earl Simpson, farmer

The life of the Iowa farm child from the mid 1930s to the 1960s, as captured by Wettach's camera, was a blend of work, play, and exploration in a home and farm environment that changed dramatically over this period. From before the turn of the century through the 1950s and later, farmers modernized by incorporating electricity, running water, and flush toilets; by replacing work animals with tractors and other machinery; and by purchasing more recreational consumer goods such as radio and, later, television. Modern toys such as bicycles, toy pistols, and pedal tractors also became more available to farm families.

Despite the increasing conveniences, most farms remained demanding work environments where children's participation was necessary to the farm's success. Some people who were photographed by Wettach as children recall an impressive list of regular chores such as feeding animals, collecting eggs, milking, carrying wood and water, herding stock, working in the field, and other routine jobs done even at a young age. Marie Swenson (now Johnson) does not remember being directly asked to do chores by her parents. Instead, she remembers simply pitching in wherever she was needed, especially when it meant that she could spend time with her father, Gust Swenson: "I always spent all my time outside . . . so [in the jacket picture of the girl shocking oats] I was over there in the field, undoubtedly barefooted, because I always remember walking in oat stubble with my bare feet. Normally that would hurt people's feet, but my feet were tough then. I was out there because Dad was out there."

Kenny White describes working alone herding cattle at a relatively young age. He remembers his pony, Dolly, as a regular companion and assistant in his chores, which included herding stock cows each day. "It was all work on the farm," according to White, who recalls a heavy load of chores as a child. White eventually used the money he earned raising capons to buy a bicycle despite his father's protests that "a kid riding a bicycle is no good for work."

Underscoring the life of a farm child were the hazards; the farm contained countless ways for an adult — let alone a child — to be injured. Wettach recognized the problem of child safety and often looked for ways that farm families had addressed this problem for his handy ideas photos. Sometimes he would pose and photograph children (especially his son, Bob) in potentially unsafe activities, captioning the pictures with warnings about the risk of injury. Ironically, these safety photos rarely addressed the hazard associated with the increasing number of farm tractors, combines, and large implements that children played around and even operated, focusing instead on more traditional sources of injury: uncovered cisterns, sharp objects under bare feet, large animals, and guns.

Most of Wettach's photographs of children, however, present them much more matter-of-factly as a regular fixture on family farms. He clearly liked to take these kinds of pictures. With an affectionate eye, he documented the participation of children throughout the annual cycle of farm life, from planting through harvest.

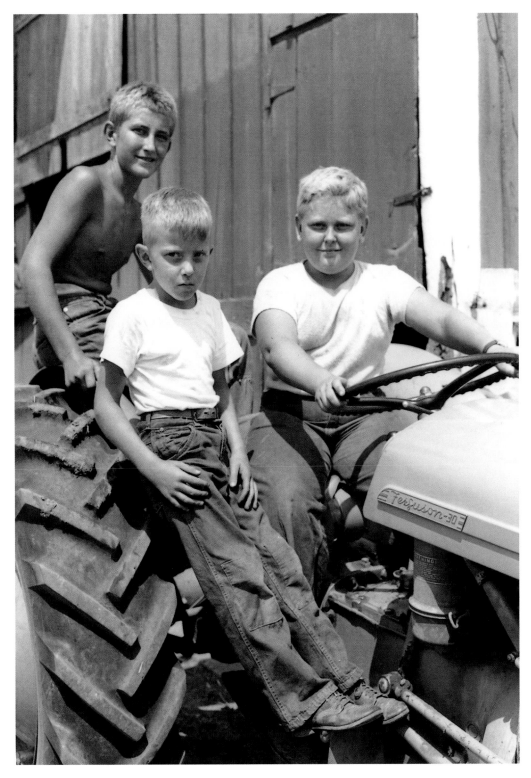

"Boys helping with farm work; one on left is 'native' & others town visitors." Wettach was well aware of the friendly rivalry between town kids and country kids, capturing this mixed company in a relaxed moment. Often these children were from urban and rural branches of the same extended family. Children visiting the farm usually got a taste of the most entertaining parts of farm life but seldom were required to do the more difficult or tedious chores.

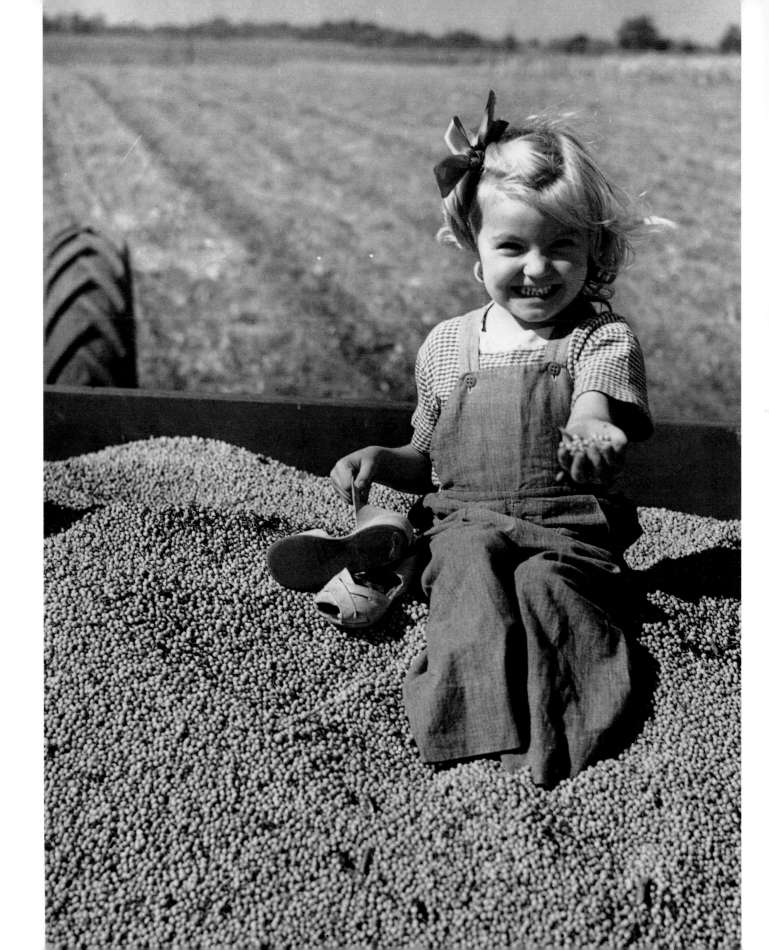

"Linda Hudachek, 4/55." This is a classic pose of a mid 1950s farm child on a toy pedal tractor that decades later would become a collector's item. John Deere dealerships sold these toys alongside full-size tractors and implements.

"Helper in Harry Bryant's bean field in Henry County, Iowa, is Harry's daughter, Patty."
From Wallaces' Farmer, *November 1, 1947.*

A girl adds ice to a jug of lemonade made for a picnic. Here Wettach is capturing one of the many ways rural electrification improved farm life. In this case, a refrigerator with a freezer compartment provides ice cubes — a luxury families without electricity had to do without.

"This four-day-old Mexican burro colt is apt to have some busy days ahead of him with these three youngsters as companions. Albert Nau children, Mt. Pleasant, Henry County, Iowa." Farm children often had animals that were pets rather than livestock or work animals. This burro was never expected to contribute much more to the farm economy than some hours of entertainment for the children, although when grown it was hitched to a buggy every now and then to take the children to school. Photo taken around 1956.

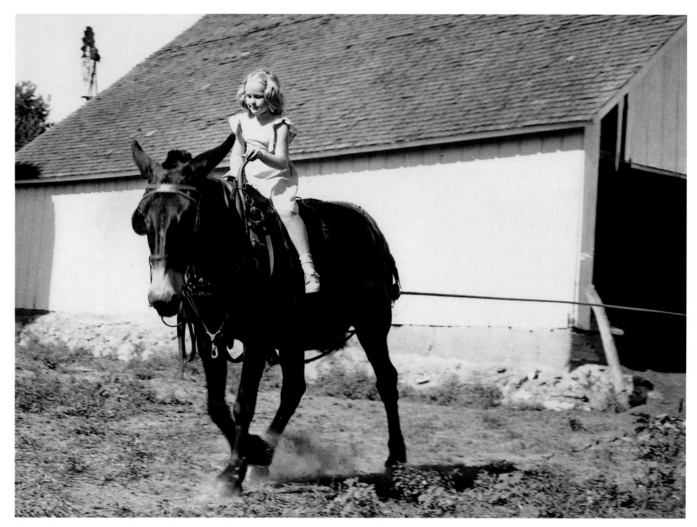

This girl is using the mule to lift loose hay or bales up into the hayloft via a hayfork and a system of pulleys. Young children, both boys and girls, were often expected to do this chore, while adults and older children attended to the heavier work.

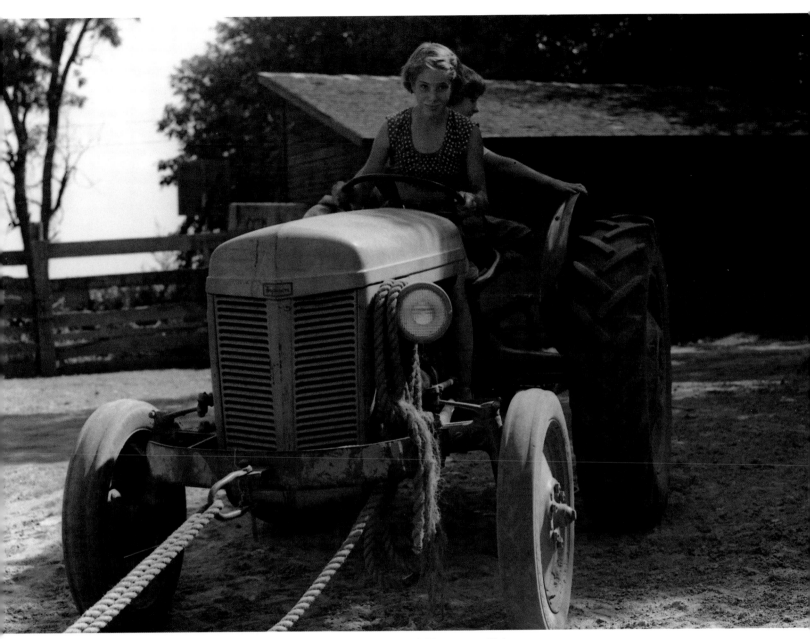

Tractors eventually replaced mules and horses for pulling the hay rope, but children were still the ones often called upon for this job. Here, another youngster watches from behind while the girl at the wheel backs up the tractor to pull the hayfork rope.

"Margaret, Caroline, Dwight & Dorothy Jorgensen and their colt, which will be a work horse in another year. Van Buren Co., Iowa." Caroline, in the center, remembered the *"man from* Wallaces' Farmer*" coming to take their picture sometime around 1942. Here, the two older sisters are wearing nearly identical outfits cut from the same bolt of cloth.* "Mother [Emma Jorgensen, pictured in chapter 2] would make us two dresses for school each year," *Caroline recalled many years later,* "and we would wear each one for the week. Then it would be washed, and we'd wear the other one."

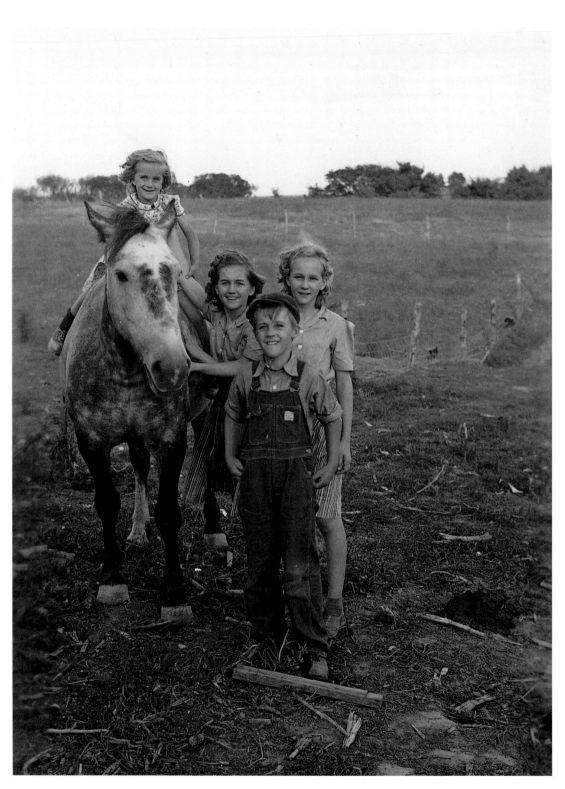

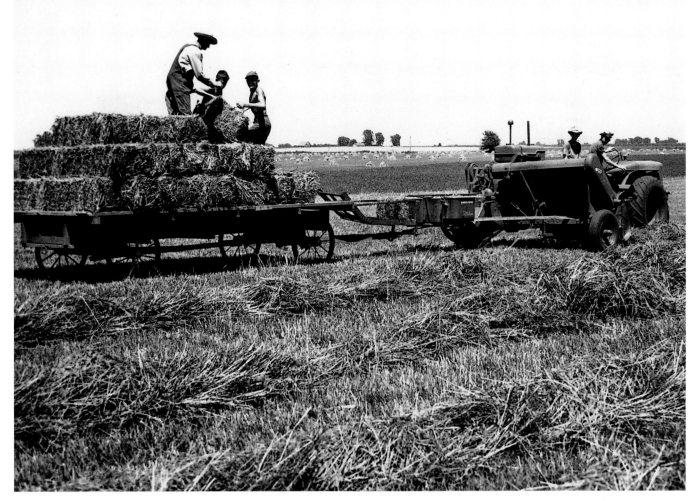

Wettach captioned this photograph "Baling hay on the George Swedenberg farm, Danville, Des Moines Co., Iowa" and added, "The boys think this is a lark." Odd nowadays to think that boys would find this job to be fun, but this automatic baler was their salvation from one of the most hated jobs on the farm: tying bales. Hand-tying was dirty, dusty work. This baler, an International Harvester 50-T, manufactured from 1944 to 1952, tied the bales automatically and delivered them directly to the wagon, where the boys would stack them.

"Making a pile of chopped forage into grass silage on the B. B. Buffington farm, #2 Mt. Pleasant, Henry County, Iowa. Two tractors in tandem are necessary to pull the loaded wagon on the packed forage." A chain attached to the front of the tractor is hooked on the back of the lead tractor. The little boy in the picture provides the extra pair of hands to keep the wheels straight. A similar photo, taken of the same scene, was published in Country Gentleman *magazine in May 1953.*

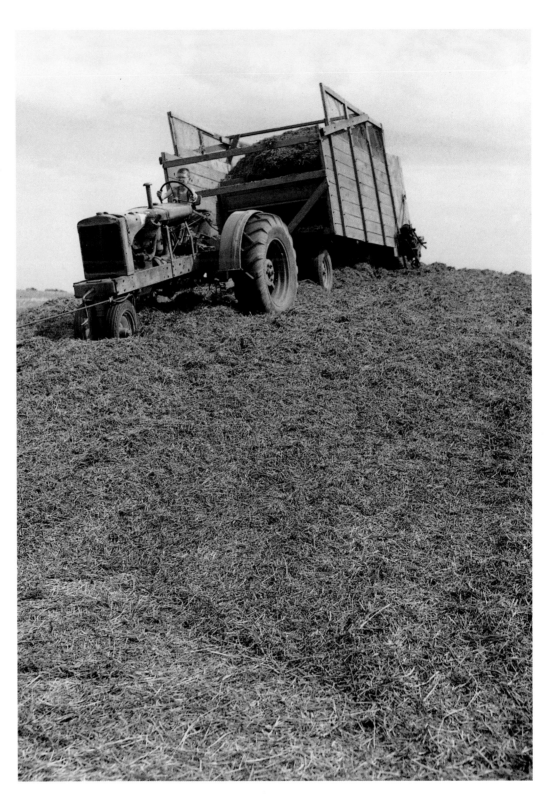

In Wettach's time, rural roads posed a danger to playing children, much as they do today. This photo had no caption, leaving to the imagination the story behind this poignant sign.

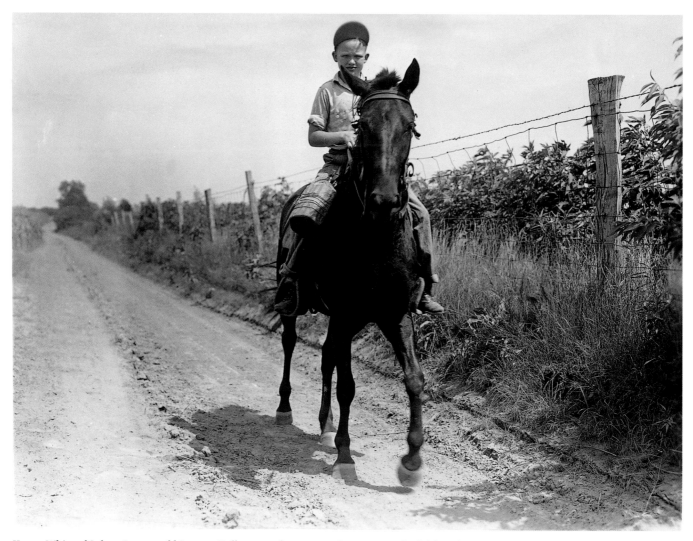

Kenny White of Salem, Iowa, and his pony, Dolly, around 1939, carrying water to the field workers.

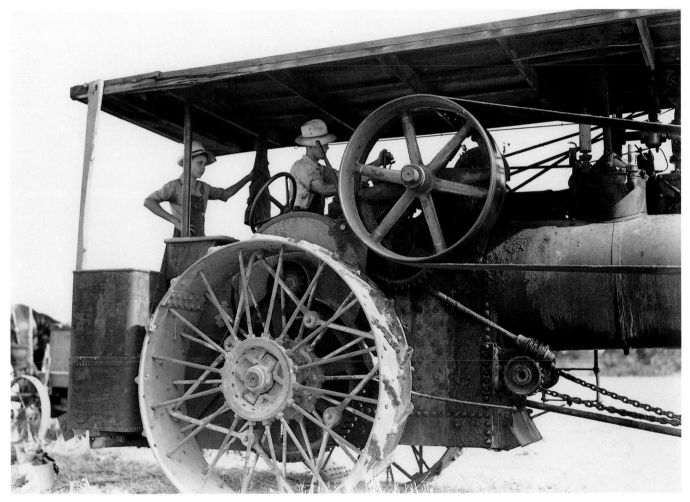

A boy stands watch on this steam engine, which has seen better days — note the wooden board holding up the canopy. Its owners likely kept it as long as possible, especially while there were enough hands around, including the older children, to help with the labor-intensive process of threshing. After World War II, the combine gradually increased in popularity, making it possible for one farmer to do most of the harvest alone. Photo taken in Jefferson County in 1940.

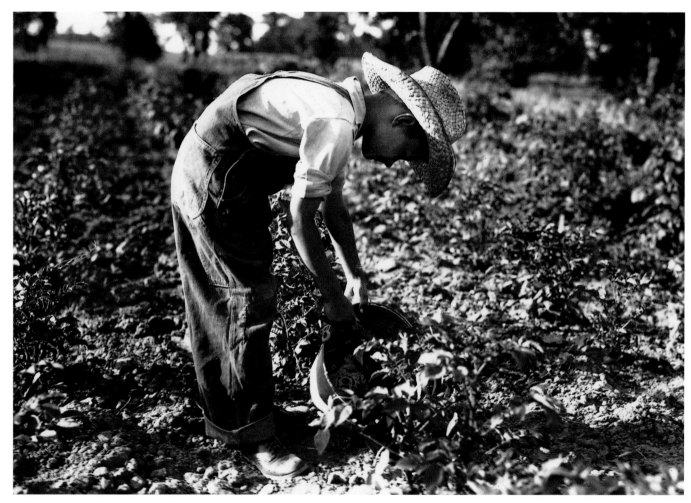

Wettach titled this photo of his son Bob "Bugging 'Taters," adding, "This is the job most farm boys do without enthusiasm. The potato bugs are knocked into a bucket by tapping the stem of the plant with a short stick. 1936."

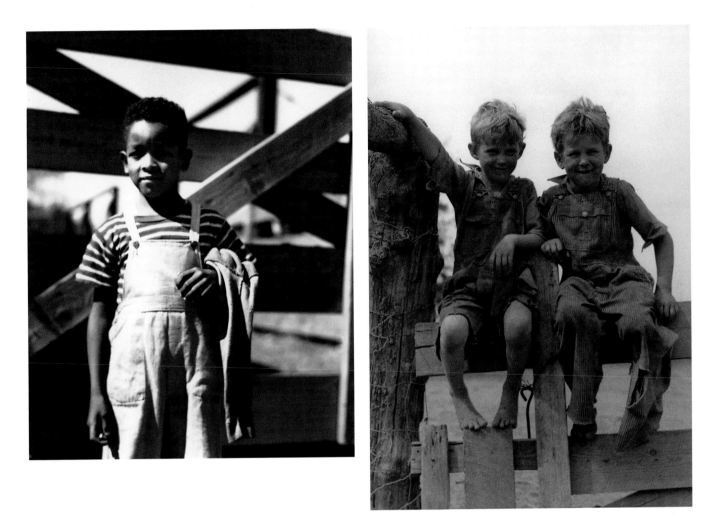

Although not all of Wettach's photographs are identified (these two are not), his images of farm children nevertheless reveal details such as what they wore every day: usually a mix of homemade, store-bought, and hand-me-down items. The photo on the left is also a reminder of the presence of black farm families in Iowa.

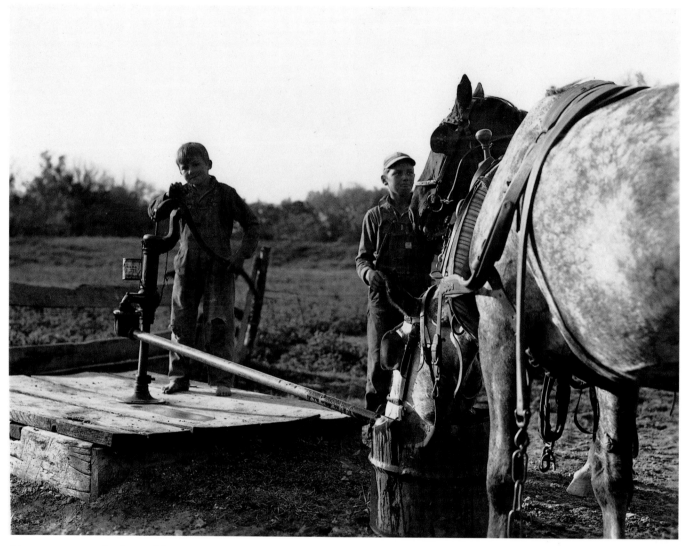

A boy pumps water for the work horses.

86

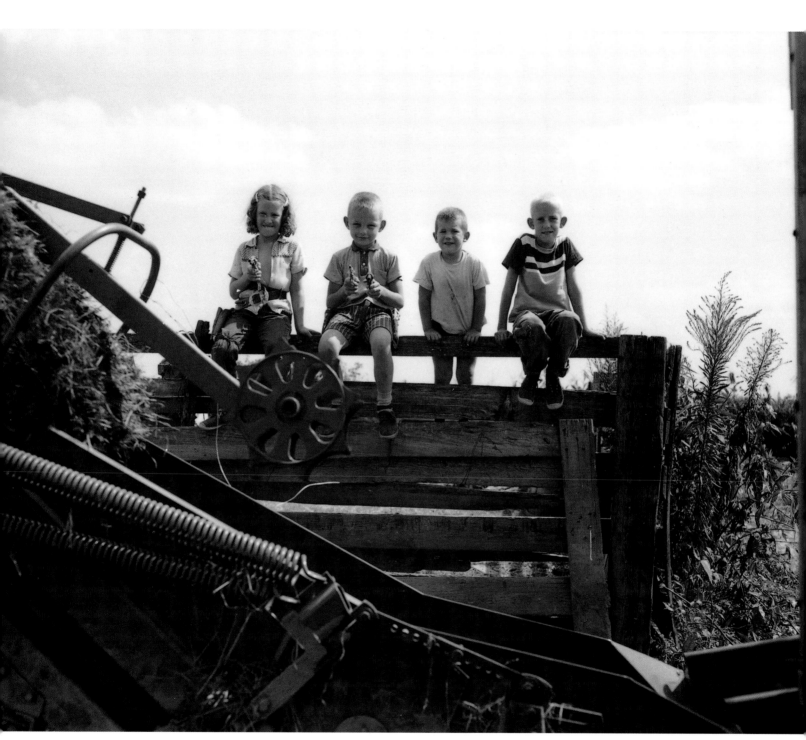

Wettach's eye for composition is evident in this photograph taken on the Payne farm near Mount Pleasant, around 1960.

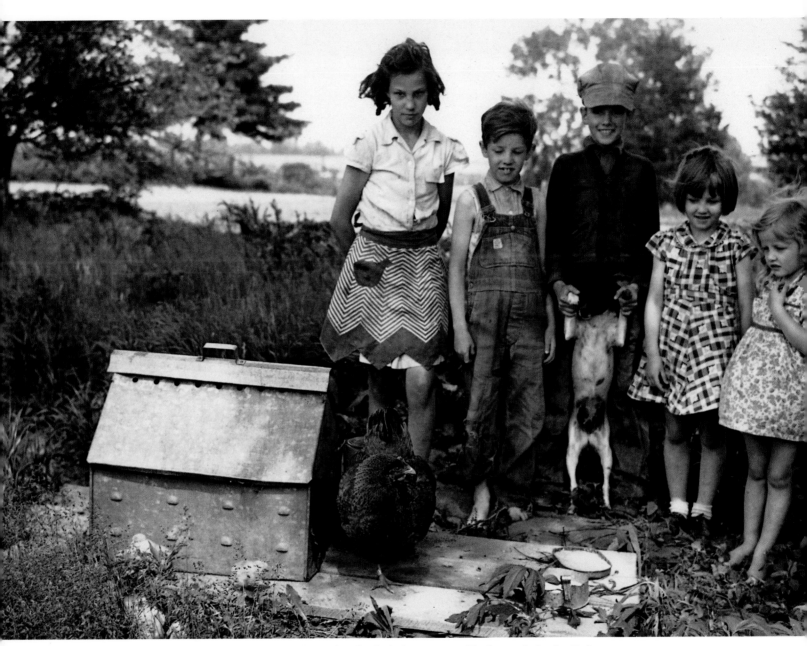

"The Rex Woodruff children admire their pet hen — but the chicks have scattered in the weeds. Louisa Co."

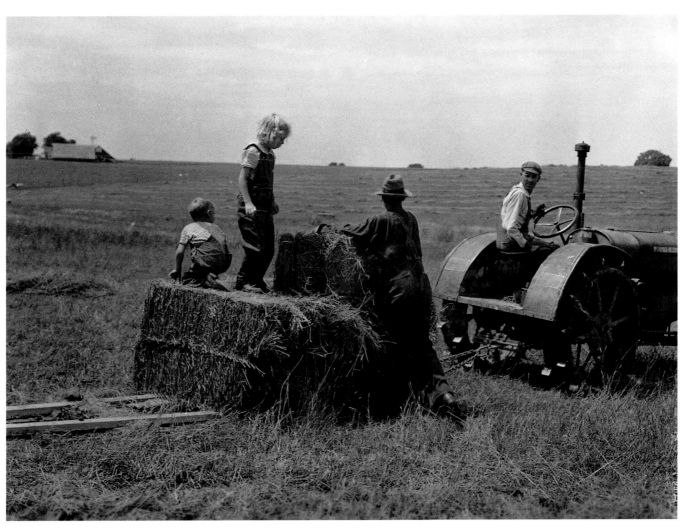

These two children appear to be more interested in having fun than in helping. Despite the heavy load of chores, the farm is often remembered by those who grew up on it as a huge and inviting playground.

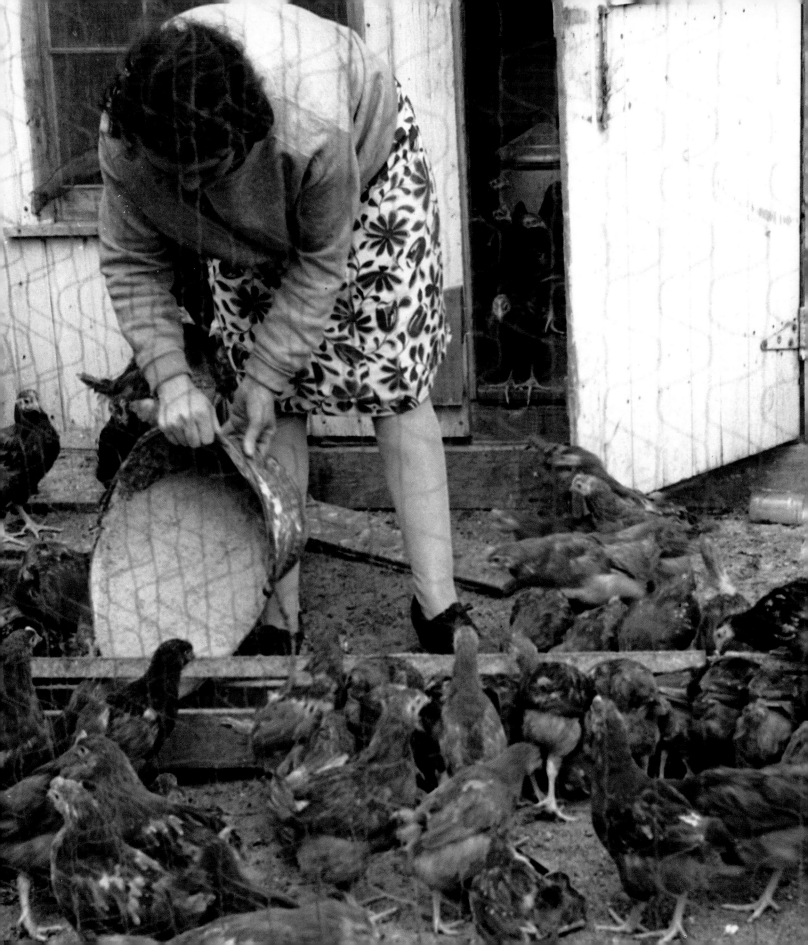

The Tenant Purchase Farms

Pete Wettach's fourteen-year career with the federal government's farm relief program launched his second vocation as an agricultural photographer. Although he had sold some photographs and articles before he left farming, his work with the Farm Security Administration took him on visits to dozens of farms across many Iowa counties, exposing him to a great variety of places and people, many of whom allowed him to take their pictures.

The FSA's Tenant Purchase program was a federally funded loan program designed to reduce the high rate of tenancy brought about by the Great Depression. Renting farmers in regions all around the country, including parts of Iowa, were given a singular opportunity to buy their own farms. The terms of the program required applicants first to submit to a rigorous evaluation, including an assessment of their financial resources; an analysis of equipment and livestock; a farming plan for the new farm; and a close look at food produced by the farm for the household, including canning practices and the nutritional value of the family's meals.

Wettach assisted families with applications and then, once they were enrolled, followed their progress through the years, suggesting changes to farm plans that would keep them solvent and on track with repayment. These long-term relationships brought

There is a good story in every county in Iowa where tenant purchases have been given a trial.

Wallaces' Farmer and Iowa Homestead *article on the FSA's Tenant Purchase program, probably written by A. M. Wettach, July 29, 1939*

him out on regular visits to client farms, often with his camera. In some cases, he photographed the same family over a course of years.

Once successful applicants were enrolled, farm and home activities were monitored by FSA staff. Many families may have found these requirements intrusive; farmers were not accustomed to being told how to run their operations or their households. This kind of social service program was new territory for both the government and for the farmers, but with applications so competitive, many willingly complied. They submitted a plan each year for crops and livestock and for feeding and clothing all household members. They were encouraged whenever possible to keep cash purchases to a minimum and to make or grow most of what they needed. For those households that did not have a pressure cooker, a grant of about fifteen dollars was provided to purchase one to facilitate the canning of fruits, vegetables, and meats.

Wettach, as a county supervisor in charge of monitoring these families, somehow managed to maintain his clients' goodwill in the face of the government's meddling and also got them to agree to be photographed. Perhaps his camera helped smooth the road. This was a time when most people had few reasons to feel uneasy about having their picture appear in a newspaper or magazine. Wettach usually offered to give them a print and a chance at a little bit of fame in one of the publications read by many of their friends and neighbors.

It is not clear how much awareness Wettach's FSA coworkers had of his picture taking, not to mention the income he earned from the sale of his photographs to newspapers and magazines, already a brisk business for him by the late 1930s. He frequently traveled with other FSA employees. In fact, some of his photographs include men and women in office attire — likely FSA colleagues — alongside those who clearly made their living off the land. There may have been some tacit or explicit understanding between Wettach and the Farm Security Administration that the publication of at least some of the photographs he took of his clients would benefit the FSA and the Tenant Purchase program.

There are no surviving personal records, letters, or journals of Pete Wettach's experiences with the FSA. However, the National Archives and Records Administration has files on many of the families from the Tenant Purchase program, several of whom were photographed by Pete Wettach. A few of these files contain correspondence and reports written by him. All are a rich source of raw data on each farm: how many acres, animals, sons, and daughters were on the farm; how many eggs were produced; the prices fetched for cream, corn, hogs, calves, wool; the buildings on the farm and what kind of condition they were in; which implements the family owned and which ones they borrowed from neighbors.

The following are brief vignettes of five of the Iowa families from the Tenant Purchase program photographed by Wettach. These short essays were assembled using National Archives documents, or oral histories, or both, and any spelling or grammatical idiosyncrasies have been left as they were written. Three of these families were Wettach's clients; the other two (the Manns and the Rummels) were clients of FSA colleagues. The lives of the Mann, the Conard, and the Rummel families emerge from a series of documents from the Farm Ownership Case Files that are now held by the National Archives and Records Administration. These documents are scattered through thick folders that are filled mostly with dry inventories and legal documents consisting of narratives from reports, forms, insurance claims, and other documents. Put together, however, they tell a story. Photographs of members of these five families, along with photos of some additional Tenant Purchase families, follow this section.

Boyd and Marjorie Brown *Salem, Henry County, Iowa*

Boyd and Marjorie Brown purchased their farm with a loan from the FSA's Tenant Purchase program in 1939. Like many other Tenant Purchase families, the Browns kept careful track of the equipment and animals they had on hand and what they would need for the coming year. At the end of their first year on their new eighty-three-acre farm near Salem, Iowa, their farming equipment included an automobile (a Model A Ford), a walking plow, a cultivator, a disc, a harrow, a planter, a harness, a gang plow, and a cream separator. Other equipment, including a binder, was borrowed.

They had four Percheron horses, expecting one more "to be produced" that year, twelve Guernsey cows and heifers, with eight "to be produced," as well as sixty capons, fifteen hogs, eighty-five poultry, and thirty sheep. A sire for the horses was available free of charge from a neighbor or relative.

Their home had a number of modern conveniences for the time: electricity, running water, a radio, a telephone, a kitchen sink — but no indoor toilet at first. They had two children then: a son, Charlie, six years old, and a daughter, Beverly, one and a half. Another daughter, Joyce, had died at the age of two in 1937 from an ailment, possibly polio, that had also sickened their son. By 1939, they still owed $84 in medical and funeral expenses. Boyd and Marjorie Brown had more than their share of illness and death among their children. Their first child, Joan, had died in 1932, three days after birth. Charlie developed diabetes at age twelve and later succumbed to the disease at the age of twenty-six.

In 1942, after America's entry into World War II, Marjorie Brown was featured in a *Wallaces' Farmer* article highlighting her success with chickens. All farmers were urged to

increase production to help feed the troops, and the Tenant Purchase farmers were no exception. Some even signed a written commitment to add extra crops, meat, or other products to their annual farm plan for the war effort. Now numbering one hundred fifty, the Browns' hens had produced 50 percent more eggs than the previous year. A combination of better feed (some of which was from grain grown by the Browns) and regular replacement of older hens with younger pullets yielded twelve hundred dozen eggs in five months and praise for Mrs. Brown for her contribution to the war effort. Wettach took the photographs that accompanied the article, which he likely wrote.

David T. and Grace Clark Williams *Mount Pleasant, Henry County, Iowa*

As a part of the Williams's loan agreement with the FSA, Grace Williams raised food for the family by planting a garden and canning a predetermined number of quarts for the winter. She also kept track of how much she spent on store-bought groceries. This requirement was to encourage Tenant Purchase families to keep their cash expenses as low as possible. All this information had to be recorded in booklets provided by the FSA. When her mother came home with groceries from the store, the Williams's daughter Leila would carefully transfer the numbers from the sales receipts into the book.

Although Pete Wettach was an FSA supervisor for the Williams family farm, he and David Williams also became good friends. Wettach occasionally asked members of the family to pose for photographs, including the one of Leila shown in this chapter, taken when she was about fourteen. For another photo, taken during the war, Wettach brought a flagpole and flag, sticking it in the ground in front of their house for a patriotic pose of a father raising the flag while the family saluted.

Ralph and Eunice Mann *Packwood, Jefferson County, Iowa*

Ralph and Eunice Mann were, in many ways, the kind of people the FSA was looking for: thrifty, industrious, and skilled farmers, as shown in their 1939 application to the TP program.

> Mr. & Mrs. Mann are thrifty American farmers. They realize that they can not have everything at once, and plan for the things they want most. They are cautions in making purchases and study the merits of the purchase before hand. . . . Good management is shown in many ways. Mrs. Mann has a large canning budget, has lard and meat on hand that has lasted throughout the summer months. She makes some of their clothing from sugar and flour sacks, and makes most of their soap. . . . This fam-

ily is industrious, thrifty and cooperative, and should be a credit to the Tenant Purchase program. The home supervisor believes they will cooperate with the program and is glad to recommend that they be considered for a Tenant Purchase loan.
—Jeanette T. Ackerburg, Home Management Supervisor

Mr. Mann is one of the most efficient farmers I have ever seen. His farming program is so sound that I would find it difficult to offer any suggestions to him. . . . I believe Mr. Mann would make an excellent Tenant Purchase client. However, one handicap to them being a Tenant Purchase family and that is, they do not have any children.
—Herman W. Zobrist, Rural Rehabilitation Supervisor

Without children, the Manns may not have come across as needy enough for the program's limited resources. Had they not impressed the FSA in other ways, this couple's application probably would not have succeeded.

The Manns made the most of the help offered by the FSA, paying off their loan in advance, in less than five years. They also eventually had two children. Their 1941 Farm and Home Plan included fifteen dollars budgeted for a "layette" and fifty dollars set aside for "confinement."

In 1944, in response to a letter congratulating them on the release of their mortgage, Ralph Mann wrote:

Received your letter in regard to the farm ownership program. We sure think it is allright and that more worthy family's could have the chance that we had.

Now that we have our home paid for we think more of it and we get a lot out of our book keeping; what we spent our money for and what it went out for. We are keeping up our book work just as if we still had our loan.

We think people that gets loans should have ever thing else clear and not have another debt on their hands or not get a loan for a farm.

And would like to see more loans put out to farmers than there has been in the last couple years.
—Yours Truelly, Ralph Mann

Arthur and Grace Conard *New London, Henry County, Iowa*
Arthur and Grace Conard were older and more experienced farmers than many of the other TP families. Although in their forties, with two of their four children in college, they

were a robust, intelligent, and energetic couple, as shown in the Home Management supervisor's narrative for their application to the program in 1939.

> Arthur and Grace are both descendants of American born parents and made their home on a farm in Indiana until 1920. At that time they moved to a farm in Louisa Co. and in 1927 to a small town in Des Moines County, Iowa where they operated a grocery store for 9 years. Mr. Conard completed 7 years of school and Mrs. C. completed 8 years. . . . Upon leaving the grocery store the family moved to the farm on which they now live. They have been operating under a stock-share lease and feel that it would be greatly to their advantage to be on a farm of their own. . . . The family as a whole seems to be exceedingly harmonious. The children are expected to express their opinion of various situations and have an active part in all plans for the future. . . . Both Arthur and Grace Conard have the feeling that anything they accomplish must be attained by their own effort. Both individuals have an optomistic outlook on life and a good sense of humor. . . . In spite of the fact that neither Mr. nor Mrs. Conard had a High School education, they are intelligent and vitally interested in up-to-date methods of farm and home management. They are most anxious that their children have better educational advantages then they themselves had.
> —Dorothy F. Wingert, Assistant Home Management supervisor

Because of the Conards' interest in up-to-date methods they were a bit of a handful for the FSA staff, including Wettach, who tried in vain to keep them in line with the farming and housekeeping practices expected of families in the Tenant Purchase program. The Conards repeatedly insisted on doing things their own way.

It began with the Farm Management supervisor's recommendation that Arthur sell the tractor and to go back to doing all the field work with horse teams. The FSA recommended this in part because he would be farming much less land than he had before, and tractor fuel and maintenance were considered to be more expensive than horses. Wettach's plan for them stated:

> At present Mr. Conard has 3 mares and 3 colts. He has a used tractor outfit and will have no need for this for the farm he will operate. He is trading it to his brother-in-law for a good team [of horses] and $550.00 cash. . . . It is our plan that 1 or 2 colts a year will be raised, and colts sold occasionally. All of the horses will not be needed and in another year, the work will be done with 4.

The Conards, however, asserted their independence. At the end of their first year, the Home Management supervisor wrote:

The total amount spent for family living, was fifty dollars less than the estimated cash living expenses for last year. However, this does not indicate that last year's plan was followed closely. Ninety-four dollars more was spent for food than planned. Their boy and oldest gir[l] were home for several months, and for quite a while they were feeding four or five extra men. Another factor is Mrs. Conard's statement: "I guess we just like to eat too well."

At the end of 1940, evaluating the Conards' first two years on their new farm, Wettach wrote:

1939 Plan: On this farm corn yield was higher than anticipated, but the oats did not amount to much. . . . They sold their tractor and a team of horses as planned. . . . This farm is over-stocked with horses. It is expected that, at least, a team will be sold this year. Horse prices are low and Mr. Conard does not like to sacrifice on his horses, although it is expensive, I think, for him to keep them when he does not have need for them.

1940 Plan: In the winter, [Mr. Conard] had rented an additional 70 A. of ground, part for corn and part for hay, buying a used tractor, paying for part of it down and contracting to pay the balance this year and $110 in 1941. Mr. Conard did this in order to get more corn ground to keep the stock he feels he needs in order to make a living on the place. . . . The extra land was contracted without our knowledge. . . . I do not feel that we can do anything at this late date, but have told him that this is contrary to the intent of the TP program. He stated that it is necessary to take on more land to make it possible to have more of an income this next year, at least with the added expense of two children in High School.

Mr. Conard's age is 44 and his wife is 41. They were farming . . . 320 acres and I imagine it is hard for them to come down to the smaller scale, since they are hustlers. . . . He is a good farmer and one who can manage to get his work done on time. With a large share of the 80 A. he owns seeded down and the large amount of horse power he has, he could handle more land and has been asked to do so by several men who have unimproved land in the community. He feels that he is not putting anyone out in farming this extra ground and it is to his own advantage to do so. I think that it is a matter of education with them.

Herbert and Katherine Rummel *Randalia, Fayette County, Iowa*

The Rummels, who lived in Fayette County in northeast Iowa, were among the first Iowa families to successfully apply for a TP loan. They lived some distance from Wettach's assigned counties in the FSA program. He may have visited this farm — bringing his camera, as always — as part of a field assignment with other FSA employees.

In Herbert Rummel's 1937 loan application, he stated: "I have farmed eleven years, on two farms. I could have stayed here but do want to have a home of my own." The home economist's 1938 narrative in support of his application stated: "This experienced farm couple is anxious to own a farm and feel that they have an opportunity to get a very good one which should provide future security for them. . . . The family is in sympathy with the Farm Security program and will be cooperative to work with. They already keep records of expenses and income so can quickly adopt themselves to that requirement in our program." She went on to describe Katherine Rummel, who "plans well keeping in mind good nutrition, economy, and intelligent use of farm produced foods, using about $200 of it in a year in comparison with $86 use for *cash* food purchases."

The Rural Rehabilition supervisor's 1939 report reveals the success the Rummels enjoyed during their first year. "This is one of our outstanding Tenant Purchase clients today. As you will remember this was the garden spot of sixty-six acres. . . . The Rummels have adapted themselves to the operation of this small farm in an excellent manner." The report also hints at a health problem that could have been the cause of Herbert Rummel's early demise just four years later: "Prior to operating the TP farm Mr. Rummel was supposedly bothered with stomach ulcers which apparently was merely a continuous nervousness caused from the worry of paying high cash rent, and the uncertainty caused in the renting and operation of the larger unit." The report concluded: "These people are extremely happy, very much interested in farming, and . . . much more successful than was expected."

Herbert Rummel died on November 9, 1943, but the forty-two-year-old widow reported to the FSA that she and her thirteen-year-old daughter, Wilma, planned "to go on just as they have in the past." And indeed this determined family paid off the FSA loan in full on August 26, 1944, in spite of losing a silo in a windstorm that spring. In October Kermit Tieg, the family's FSA supervisor, summed up the family's experience:

In answer to your letter of September 25, 1944, regarding the payment in full of Mrs. Rummel's loan, the source of funds used to retire the loan were from farm income. In other words, she did not use any of the proceeds from the sale of the farm

nor from the sale of her other capital goods. The deed of release was recorded today, October 7, 1944.

You may remember the Rummel's from your experience in Fayette Co., so it might be of interest to you to know why she sold the farm. As you know, Herb died from cancer a year ago in November and since that time Mrs. Rummel has operated the farm and has done very well. However, she is now afflicted with a heart ailment and has been ordered off the farm by her physician. She was very reluctant to do so as they were so attached to the farm and the livestock. She had a registered herd of holstein cattle, all of which were sold to some TP families in Wayne County. The day we were dealing with the cattle she was so broken up over having to sell the herd that it was very difficult for her to even complete the transaction. The fact that they went to TP families seemed to ease her mind as she has deep feeling towards other TP borrowers and the Farm Security Administration.

Here was a family that really appreciated the help that the Farm Security Administration gave them.

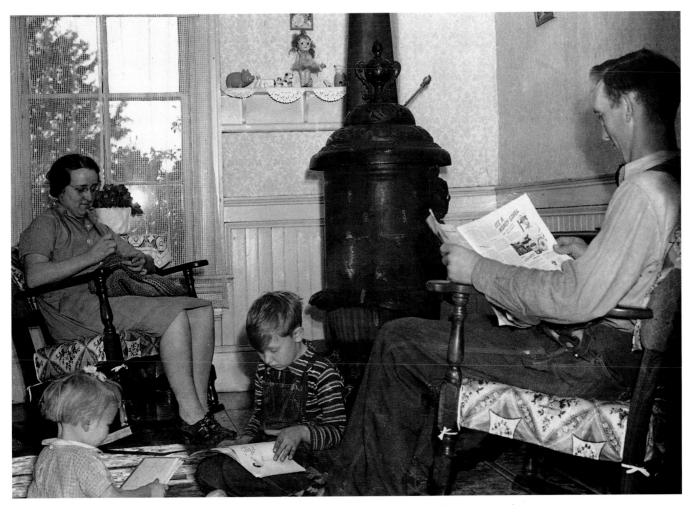

Boyd and Marjorie Brown of Salem, Henry County, Iowa, and their children, Beverly and Charlie, around 1940. This photo was probably taken when Wettach, who supervised this and many other farms holding FSA loans in several southeast Iowa counties, made a routine client visit. The photograph appeared in Wallaces' Farmer in 1940, just after Thanksgiving.

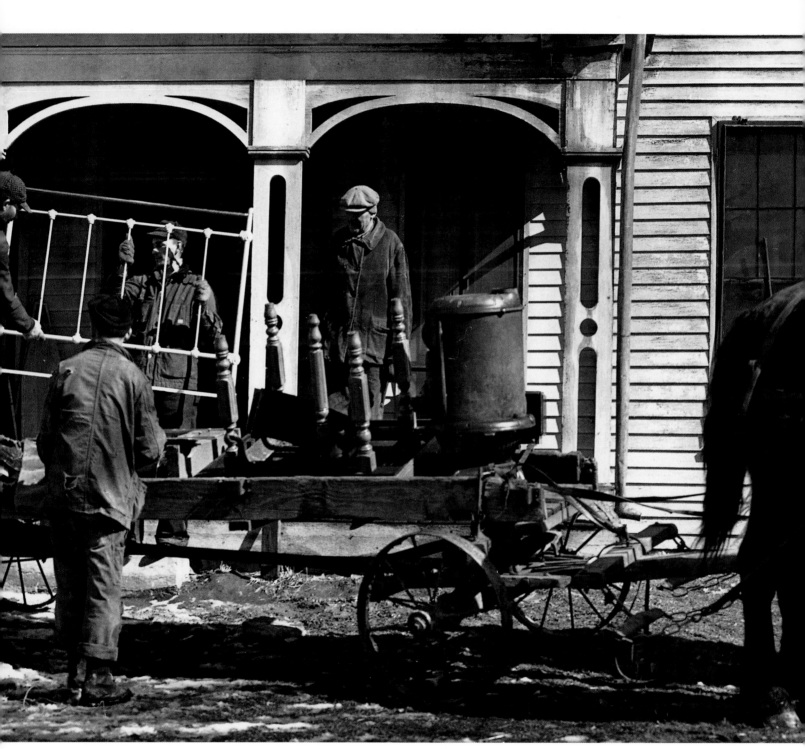

"Moving time — March 1st, on the farm, a neighborhood-sharing event in early days & neighbors still help but use trucks. Last move to own place — photo 1939." March 1st was the day that farm leases typically expired. Shown here, the Triska family of Salem, Henry County, was one of the rare renting families during the Depression that was able to buy its own farm with the help of the program Wettach administered.

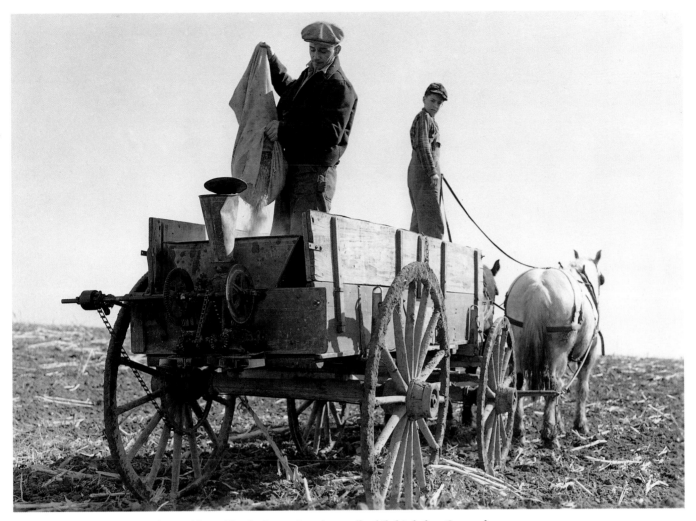

Helping to sow oats, young Robert Triska guides the horses in a slow walk while his father, George, keeps the end-gate seeder filled. This photo appeared in Wallaces' Farmer *in March 1944.*

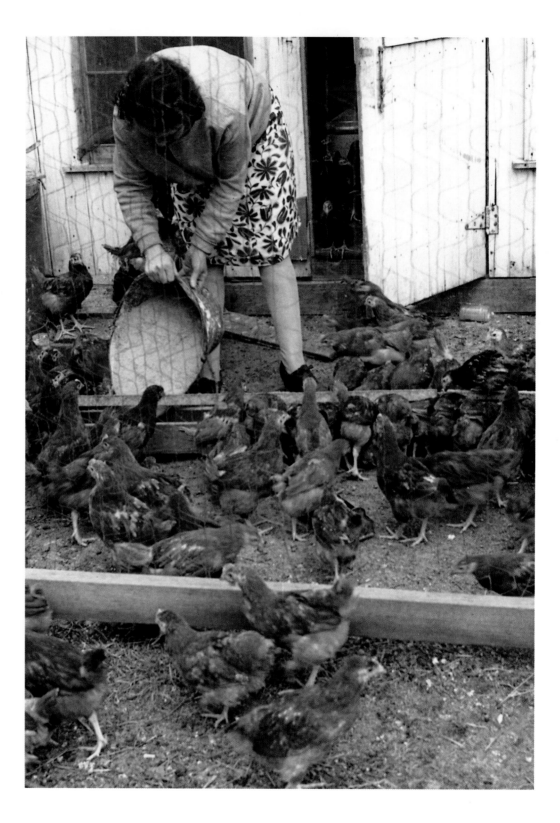

"Mrs. George W. Triska. Henry Co." Early 1940s.

Opposite: "Mrs. Ralph Mann, Jefferson Co., (TP) and part of her canning." Photo taken around 1940.

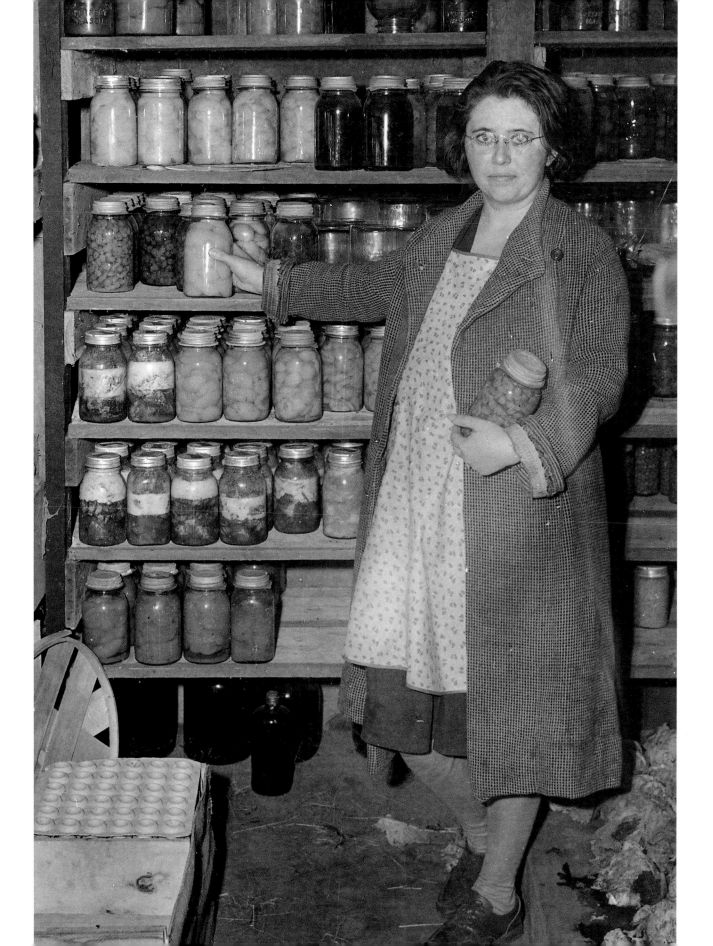

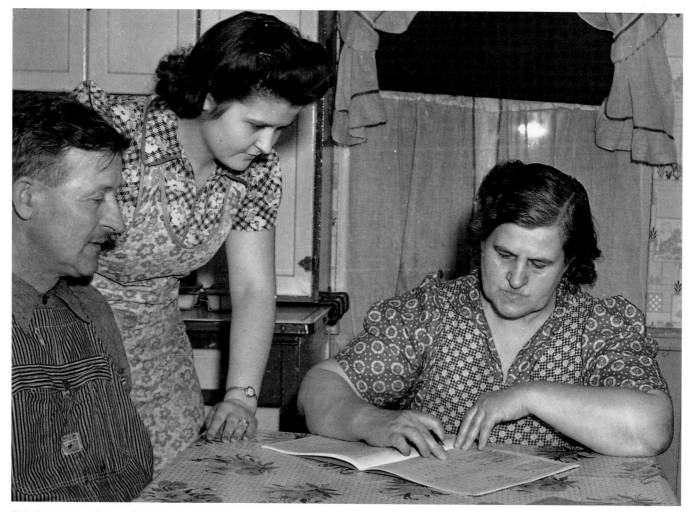

"Mr. & Mrs. Jim Shaw and daughter Gladys know by their farm account book that their chickens have been doing well. (Fayette Co. FSA.)" During the Depression, the Farm Security Administration and other farming organizations encouraged farm families to keep scrupulous financial records. Some provided preprinted booklets to calculate cash flow, helping them keep track of the farm's financial health through changing markets and farm productivity. Late 1930s or early 1940s.

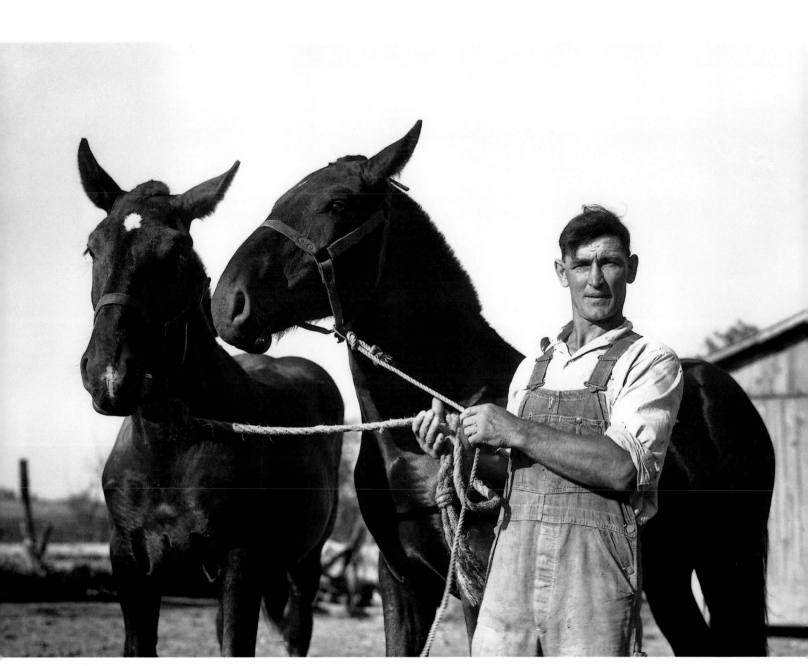

Arthur Conard and two of his horses, 1939.

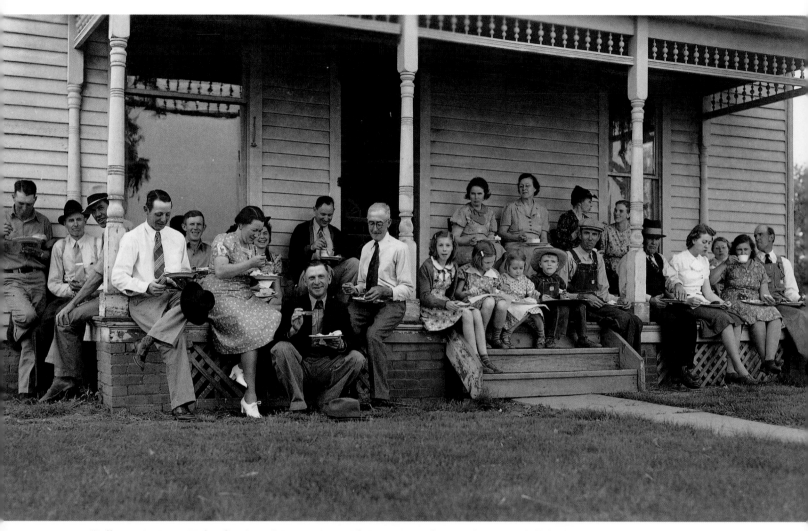

"Jefferson Co. Iowa. TP families (seven) & committee with Supervisors of FSA make a tour of all the farms purchased in the county." Taken around 1941. Photo printed courtesy of Midwest Old Threshers Museum.

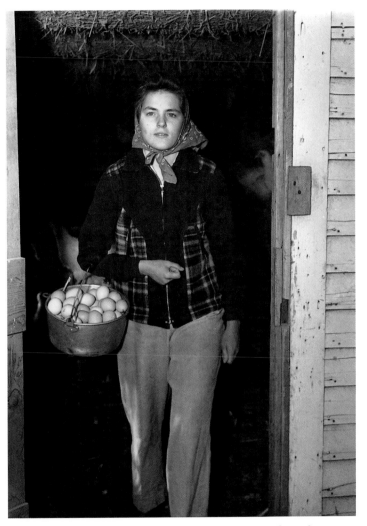

"Leila Williams, Henry Co., Iowa." This photo, taken in the early 1940s, appeared in the December 12, 1946, issue of Wallaces' Farmer.

"Herbert F. Rummel, Fayette Co. has one of the first & the smallest (66 acres) TP farm in Iowa. (World War I veteran — was disabled)." Early 1940s.

Opposite:
While family members salute, David Williams of Mount Pleasant, Iowa, hoists a flag in front of the farm home they bought through the Tenant Purchase program.

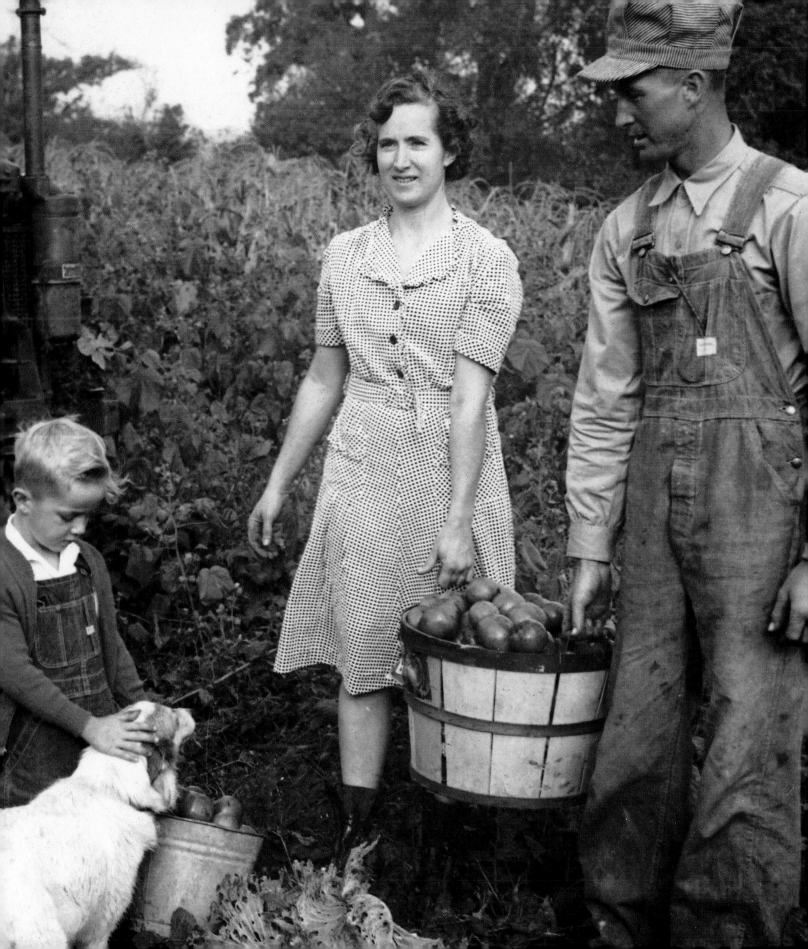

Relying on Each Other

Pete Wettach took thousands of pictures of people at work. People building, harvesting, planting, cooking, canning, butchering. People feeding their livestock or fertilizing their crops. Work at home, in the yard, in the fields, in a factory. Work with horses and with machines, on foot and in automobiles or trucks. Children, older folks, men, and women, attending to the daily demands of farm life, all appeared regularly in the photographs Wettach took year after year.

What is striking about many of his pictures is how they show people pitching in together. Given how isolated farming may appear to the nonfarmer, a common misconception about American agriculture is its solitariness; in fact, it was (and still is) a very social and community-oriented way of life. In his search for subjects to photograph, Wettach took pictures of both the well-documented group activities on the farm, like the gathering of families to help bring in the harvest, as well as the more mundane daily chores.

One example of the importance of community is the rural electrification effort of the late 1930s and 1940s. Although by this time city dwellers had long had access to electricity, utility companies balked at the costs of bringing electrical power to rural communities. When the Rural Electrification Act was enacted in 1936, many farm communities jumped at the opportunity, using all-volunteer cooperatives whose members traveled

In great harvest seasons like that one, the heat, the intense light, and the important work in hand draw people together and make them friendly. Neighbors helped each other to cope with the burdensome abundance of man-nourishing grain; women and children and old men fell to and did what they could to save and house it. Even the horses had a more varied and sociable existence than usual, going about from one farm to another to help neighbor horses drag wagons and binders and headers.

Willa Cather, One of Ours

from farm to farm signing up members, plotting lines, obtaining easements, and building the lines. Largely because of the efforts of these cooperatives, farm electrification in Iowa rose from 14 percent in 1935 to 90 percent in 1950. Wettach took many photographs of the dramatic ways in which electric power transformed the family farm.

Another frequently repeated theme in Wettach's pictures is his focus on the activities surrounding the harvest. These kinds of images are especially numerous in the earlier years of his photographic career, when harvesting was still largely a group effort. Before the combine became a common fixture on midwestern farms, harvesting small grain required many steps and many hands. It was an exciting and dramatic event with enormous machines, plenty of noise and smoke, and friends and family on hand. In the era of the giant steam-powered threshers — from the late nineteenth century through much of the first half of the twentieth — people would gather to harvest oats, wheat, or other small grains. Some half-dozen families, consisting of every available adult and child, would start on the farm where the crop was ready first. One farmer may have put up the capital to buy and maintain the large engine and the equally impressive separator (or threshing machine), while the others would be members of the threshing ring, paying their share in cash and labor for the use of the machine and the extra hands to operate it. Women and older girls who were not needed to help with the field work prepared large meals for the hungry workers. Children brought drinking water or helped with other jobs as they were able.

The threshing ring provided both a social and a business network that linked farm families. It was not uncommon for rings to be made up of families with similar backgrounds; families that threshed together often attended the same church or could trace their roots to immigrants from the same countries. Marriages occasionally linked families that were members of the same threshing ring.

New agricultural technology dramatically changed the social nature of harvest time, eventually converting a process that needed a dozen pairs of hands into a job needing only one or two. The tractor operating a smaller separator was the first step in this change, followed by a tractor-pulled combine and eventually the self-propelled combine. Although early versions of the combine, or "combination" machine that both picked and separated the grain from the straw, appeared in the late nineteenth century, it would not become popular on midwestern farms until the 1950s. The combine and other advances allowed farmers to independently manage many more acres of land, but the labor-saving machinery also contributed to the more solitary nature of late twentieth-century farming.

Photographers, painters, writers, and poets have crafted many works of art out of their experiences watching or participating in the harvest during the era of the threshing machine, and Wettach, who did his share of threshing work, was no exception. But as the less "romantic" technological advances made their way into midwestern farms, Wettach did not lose his enthusiasm for photographing farm scenes and people. He was just as inclined to take pictures of firsts — the first combine, or the first automatic baler, or the first television, as each made its appearance — as of lasts, such as nostalgic glimpses of threshing machines or horse-drawn buggies before they were completely abandoned.

In his search for subjects to photograph, Wettach found ways to describe over and over again the interdependence of people in farm communities. Families relied on all their members — adult and child alike — to make the farm succeed, and they also relied on their links with other farm families. Wettach recorded these themes with his camera in great detail, leaving us to savor many impressions of the midwestern farming community in the mid twentieth century.

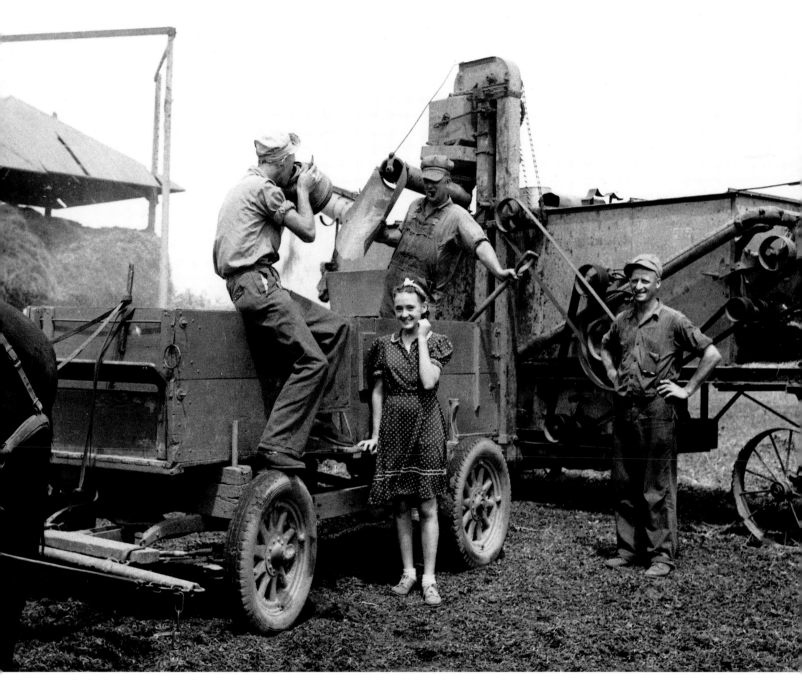

A little abashed but enjoying the company, this girl was photographed as she brought water to the men working on a threshing ring near Conesville in Louisa County, Iowa. Probably late 1930s or early 1940s.

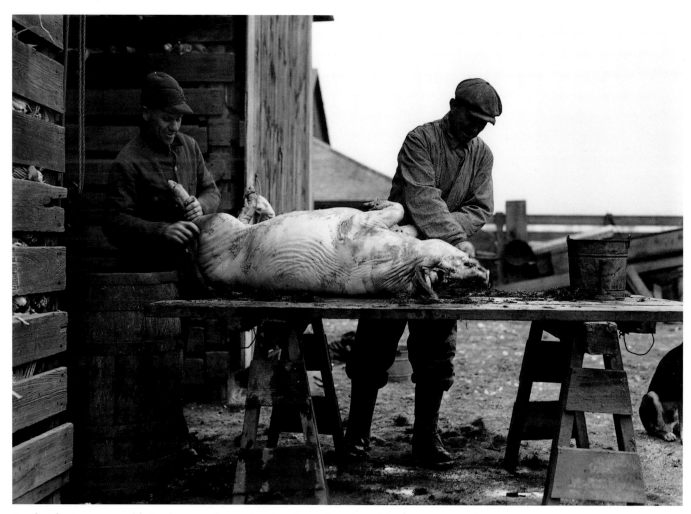

Hog butchering, an age-old ritual on countless midwestern farms. Even though it was a common chore on farms throughout the country, it was seldom photographed in great detail. These are two of more than a dozen photographs taken by Wettach on a winter day around 1939 on the A. R. Kennedy farm in Henry County, documenting each step of the butchering process. Kennedy and Harold Nelson scrape off the hair after the carcass is scalded in a barrel of boiling water and then remove the entrails. The meat from this hog will be cut up and preserved, providing bacon, sausage, and ham for the family.

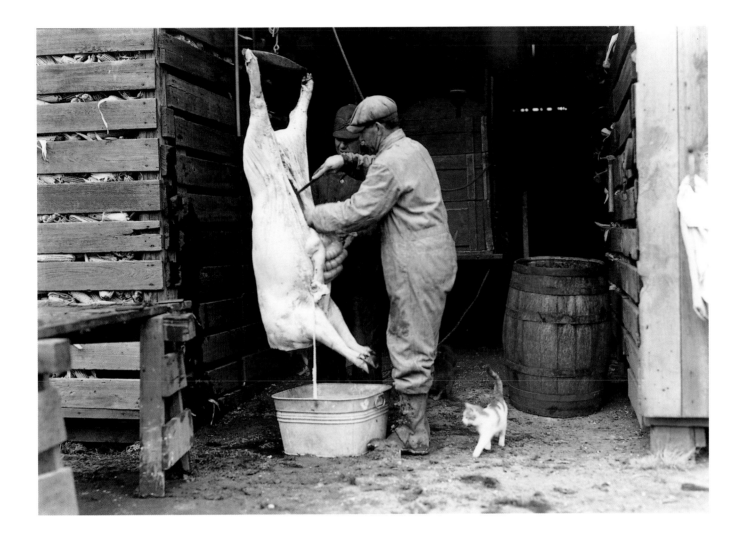

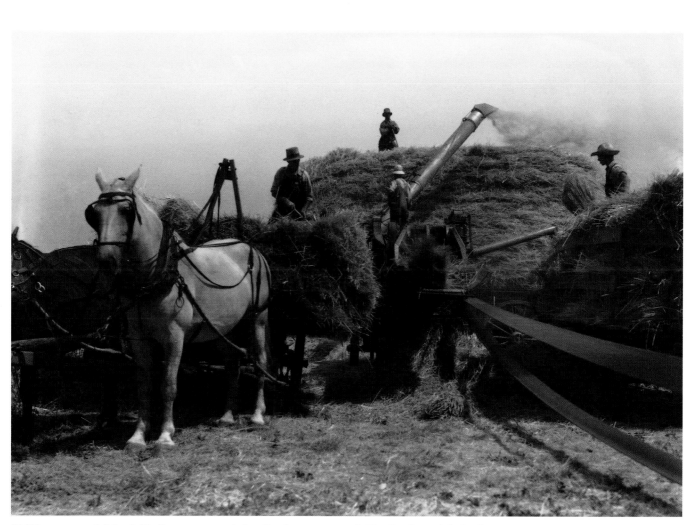

"Ed Vermazen on left load. Mr. Dawson on stack. Lou Boyd on separator & Glen Curtis on right load. 1935 or 36 — at Ralph Wright's." This photograph taken near Montrose, Iowa, shows four men, each from different families, helping thresh grain on the farm of a fifth family. The African American man on the top of the straw pile, Mr. Dawson, worked for Ralph Wright as a hired man. Dawson was from one of the few black families in Montrose, Lee County, but other sections of the county had surprisingly large black populations for predominantly white Iowa. By 1940, Lee County had more than 1,200 black residents, a decline from a high of 1,679 in 1880. Many freed slaves from the South crossed the county's eastern border, the Mississippi River, after the Civil War, looking for work in river towns such as Keokuk and Fort Madison. Their descendants stayed in the area and some of them, like the Dawsons, farmed.

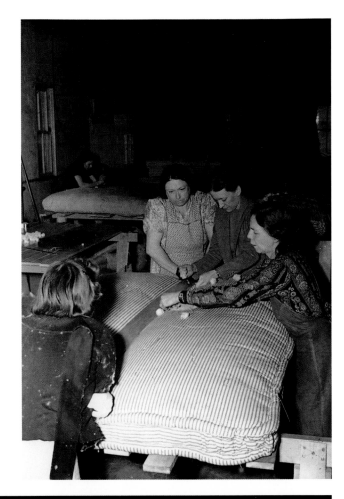

Wettach recorded the process of making cotton mattresses in a small mattress factory in Wapello, Louisa County, Iowa, 1941. Customers could save some money by making their own beds, assisted by experienced workers.

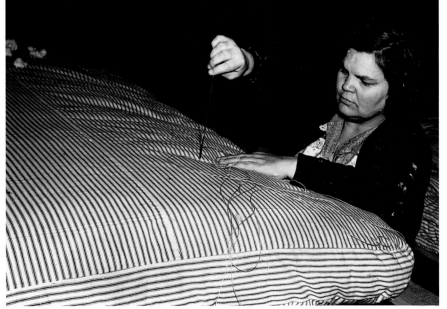

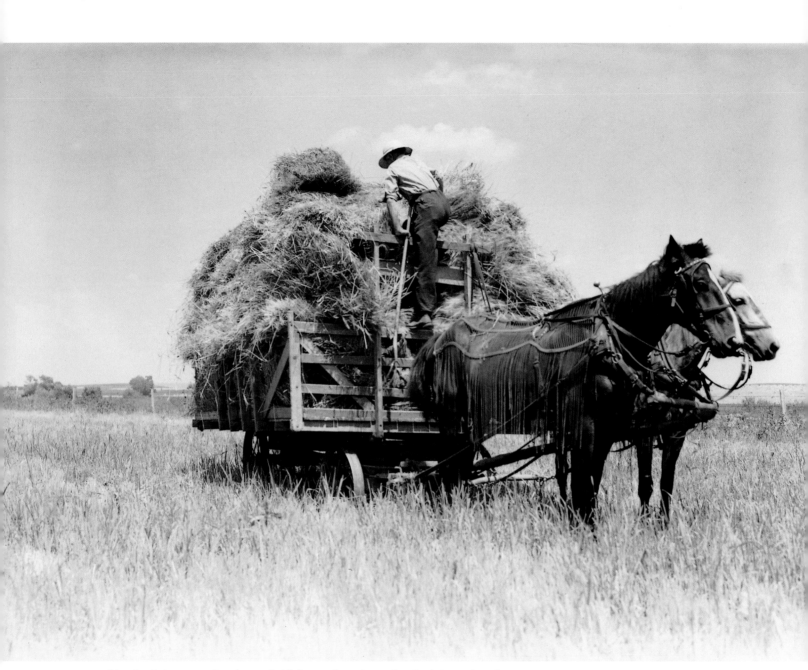

Working for their supper, these horses (with fly nets draped over their backs) stand ready to pull a wagonload of oat bundles to the threshing machine. Oats were commonly grown on midwestern farms to feed horses and mules that in turn provided the "horsepower" for many farm activities. During World War II, however, the tractor finally came of age, with 690,000 tractors replacing two million horses and mules nationwide. By 1955, there were more tractors than horses providing power on American farms. When increasing mechanization put these work animals out to pasture, the oats to feed them vanished from most farm fields as well.

Thanks to the collective efforts of many, this farmer now has a light to help him shave.
Catherine Seyb, daughter of Ralph Curtis, of Montrose, Iowa, remembered Pete Wettach
taking this picture of her father in 1945, because they had "just had electricity put in
[the] home, so [he] took the picture of him shaving as there were lights by the mirror."

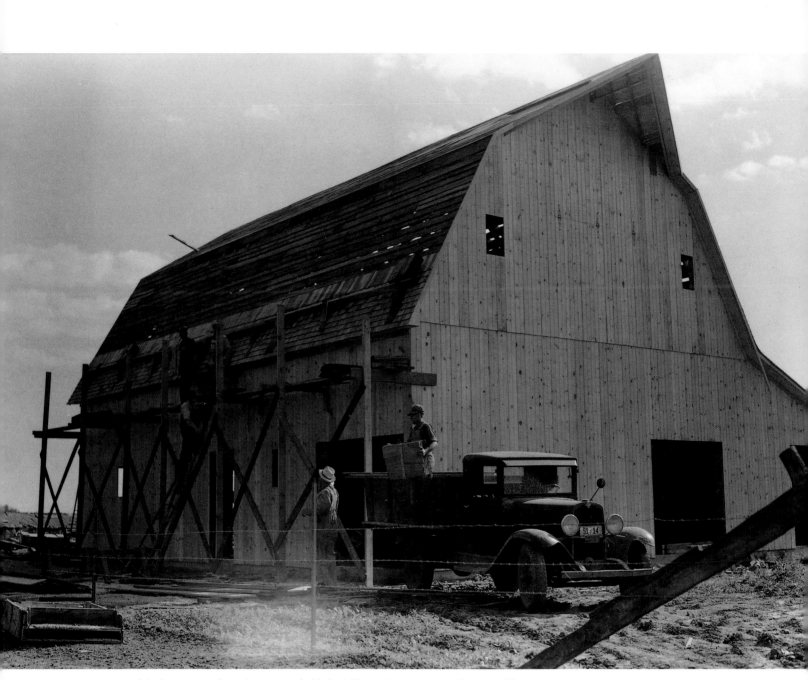

Men put shingles on a new barn in 1941, probably in Jefferson County, Iowa. These small barns with haylofts became obsolete only a few decades later when horses and mules were no longer used for farm work and livestock herds were either sold or became much larger, thus requiring more specialized shelter. Despite the architectural beauty of many older barns, farmers ran out of things that could be conveniently put in them. When they fell into disrepair, they were seldom rebuilt.

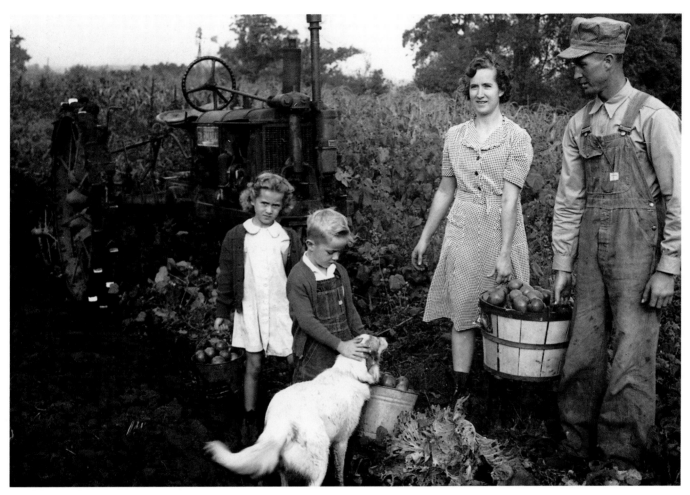

Geraldine and James Middleswart and their children, LaVerne and Phyllis, of Warren County, Iowa, bringing in the last of the fall tomatoes before plowing the household garden. Their picture appeared in Wallaces' Farmer *on September 1, 1945, along with pickle recipes sent in by readers.*

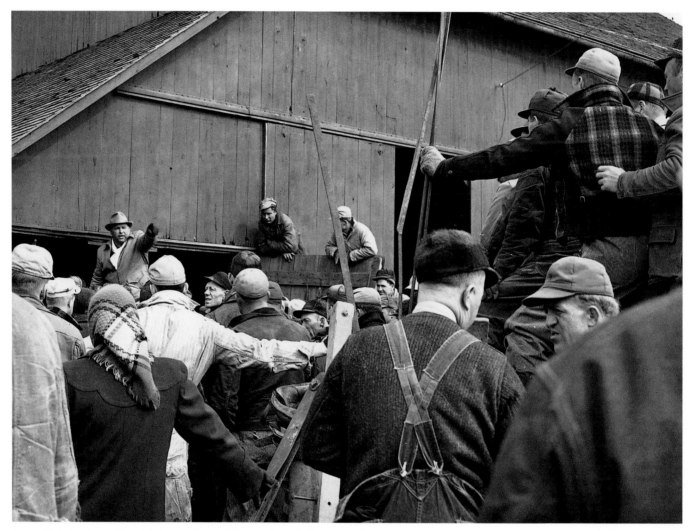

"Farm Sale." This auction, held around 1950 in Henry County, Iowa, may have been necessitated by anything from a retirement to a foreclosure to the death of the owner.

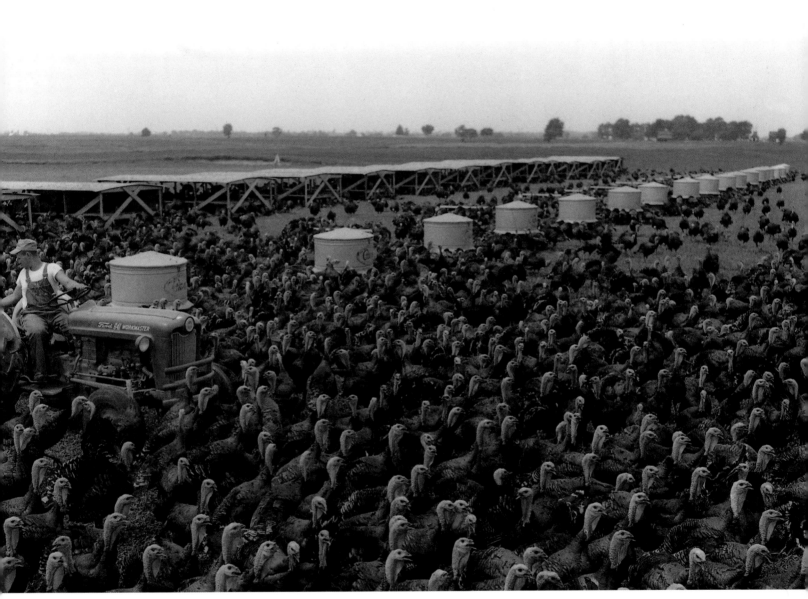

As a former turkey farmer, Wettach was probably impressed with this scene, taken in the late 1950s or later, of 4,800 tom turkeys moving en masse away from the tractor. Turkey farms of this size were unheard of when Wettach had raised turkeys decades earlier. With no tractor, no running water, and no electricity, his peak holiday bird sales during the 1930s numbered only in the dozens.

A field day, probably taken in the 1950s or early 1960s. On an educational outing likely sponsored by the local extension service, a farmer speaks into the microphone while others listen. Fertilizer and seed sellers also used these events as an opportunity to peddle their wares. As technology and scientific methods for agriculture advanced, farmers were encouraged to learn from each others' successes or to try new techniques or products used by their neighbors.

"Corn detassellers. School boys & girls." Wettach's skill with black-and-white photography as well as his sense of humor are evident here, as he captured the faces of dozens of teenage boys and girls peeking from among the stalks of corn. The tassel on top of the corn stalk was broken off by hand to prevent self-pollination. Because detasseling was a labor-intensive job lasting for a short and specific time in the summer, this farmer is using a large group of students to help. The ones seated above the crop are on a device attached to a tractor that allows them to sit while breaking off tassels as the tractor moves through the field. The others, standing, may be hoeing or may be detasseling the old-fashioned way. Taken around 1960.

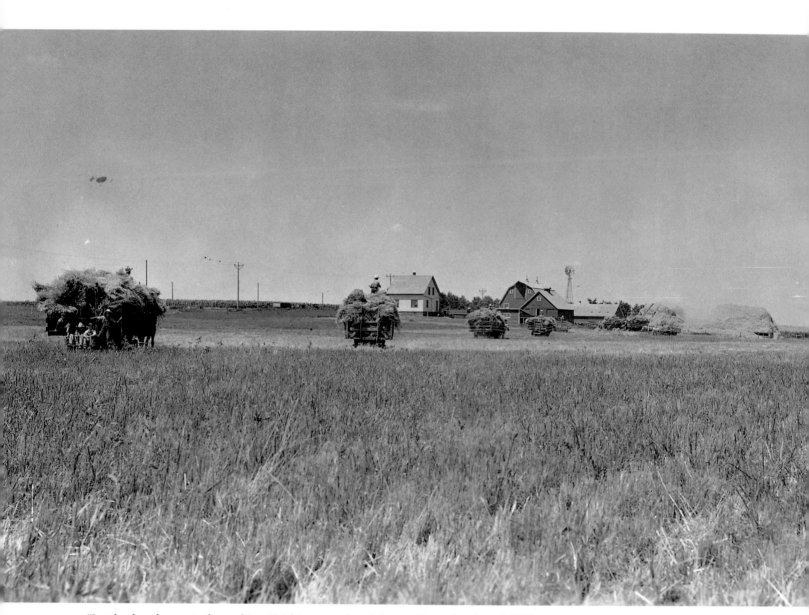

"Last load on the way to the machine. Finishing up a wheat field near Hawarden, Iowa." Children hitch a ride on the last wagon going to the threshing machine, where the work may continue until dark. Probably taken around 1940. Photo printed courtesy of Midwest Old Threshers Museum.

Notes on the Photographs

I found most of the photographs for *A Bountiful Harvest* among prints and negatives that were donated to the State Historical Society of Iowa by Dr. Robert Wettach. There were two other important sources of images and captions, however. One was the Midwest Old Threshers Museum in Mount Pleasant, Iowa, which has several hundred Wettach prints in its archives. The other was Reiman Publications in Milwaukee, Wisconsin. After Pete Wettach's death Reiman purchased a large quantity of prints from the Wettach family, using them as a source of stock photos for several of their magazines. Fortunately, staff at Reiman kept the Wettach prints housed in the photographer's original filing system, adding to their value as a source of research material.

Both the Midwest Old Threshers Museum and Reiman Publications provided me with unfettered access to their holdings. Many captions, dates, and related pictures that held important clues about the people and the scenes Wettach photographed would have been impossible to find without the generosity of the staff of both of these organizations.

The copyright for most of the photos in this book is held by the State Historical Society of Iowa, which houses the majority of Wettach's negatives. However, in some cases a print was used from either the Reiman or the Midwest Old Threshers collection for which no corresponding negative could be found. The sources of these photographs are listed below. Otherwise, all images in this book are printed courtesy of the State Historical Society of Iowa.

Jacket

Background information from an interview with Marie Swenson Johnson.

A Really Nice Paintbrush

Page 18: Caption source, Reiman Publications.

Page 19: A similar photo of the same girl appeared in *Wallaces' Farmer and Iowa Homestead* magazine on October 5, 1940.

Page 20: A photo of this car without its driver appeared as part of a photo montage about accident prevention in *Wallaces' Farmer and Iowa Homestead* magazine on March 11, 1939, with the caption, "This automobile went sma-a-s-sh when the driver failed to slow down for mud which had been brought onto a paved highway by cars off side roads."

Page 27: "Lou Vermazen (?) on load pitching bundles, Ralph Wright on stack. Lew Boyd cleaning up around separator, Smith Wright on grain wagon. Ralph Wright's farm. 1925?" These were neighbors of Wettach's in-laws, the Grimes. The date "1925" was also written directly on the negative. Wettach's caption taken from photo album of Olive Megchelsen, a cousin of Ruth Wettach.

Partners on the Land

Page 35: Background information from an interview with Caroline Jorgensen Engdahl.

Page 37: Background information from an interview with Mabyn Jensen Fox.

Page 40: Background information from interviews with Verana Grant Johnson, Loren Nolting, and other family members not pictured.

Handy Ideas

Page 53: Wettach's caption reads, "3 Model A — old tractors on 8-14″ plows — later replaced by two John Deere '70' tractors."

Page 54: An index card for this same photo has the caption, "Bug trap, Roy C. Sable #1 Packwood, Jeff. Co. Small cage blower, 1/10 HP or so used on oil furnaces (forced draft) & sock. Blower sucks in bugs."

Page 56: Another version of this same print has the caption, "This concrete back porch and cistern platform makes a good place to wash. Now is the time to do that concrete work, the long delayed walk for instance, before corn shucking."

Page 57: This family was identified as a Tenant Purchase client family in a *Wallaces' Farmer* article dated October 5, 1940.

Page 63: Background information from Thelma Coon.

Page 64: Background information from Thelma Coon.

Children on the Farm

Page 71: A similar photo identifies the boy at the wheel as Butch Johnson and the boy without a shirt as Ray Swartzendruber. The third boy is unidentified. Taken on the Everett Young farm, Mount Pleasant, Iowa.

Page 72: Background information from an interview with Patricia Bryant Doak.

Page 75: The children's names and ages at the time of the photo are, from left to right, Chris, 7; Kathy, 6; and Tom, 4. Background information from an interview with their mother, Mary Nau.

Page 78: This photo appeared on the front page of *Wallaces' Farmer* with the caption, "Bright, healthy children are big assets on many low income farms. This group belongs to the family of an owner-operator, who was drouthed out in the west but is getting a start again in Iowa." Background information from an interview with Caroline Jorgensen Engdahl.

Page 80: An alternate caption written by Wettach reads, "It takes two tractors to pull the loaded wagon of chopped green forage up on the pile that is to be used for long grass silage. B. B. Buffington farm near Mount Pleasant, Henry Co., Iowa. Color almost identical, *CG [Country Gentleman]* May '53." The *Country Gentleman* version of this scene was in color. Wettach took color slides later in his career but probably never had a darkroom set up to develop color prints. Instead, the magazine may have hand-tinted his photograph for publication.

Page 82: Background information from an interview with Kenneth White.

Page 83: Wettach's caption on a similar print from this scene reads, "Threshing on the H. Atwood farm, Jefferson Co. Iowa, steam engine is a J. I. Case burning wood, one of the last to travel this part of the state. Photo taken in 1940."

Page 87: The children, from left to right, are Beverly Payne, Frank Marshall, Dickie (Richard) Payne, and Greg Hummell. Dickie is about five in this photo and the rest are about eight years old. The Payne children are cousins of the other two. Background information from Pauline Payne and Frank Marshall.

The Tenant Purchase Farms

Page 101: Background information from interviews with Marjorie Brown and Beverly Brown Hamm and from National Archives and Records Administration files.

Page 103: A *Wallaces' Farmer* caption from March 18, 1944, reads, "Clover can be sowed with the oats if the ground is very dry. With plenty of moisture, results may be better if grass seed is sowed separately and rolled or disked for cover." Background information from Robert Triska and Jan Triska Moxley.

Page 105: Background information from Dot Hellkamp of the Jefferson County Historical Society and from documents at the National Archives and Records Administration.

Page 107: This photo appeared on the cover of *Wallaces' Farmer*, July 29, 1939, for an article about the TP program but, oddly, the magazine cropped out the horse on the left. Background information from National Archives and Records Administration files.

Page 109: Background information from interviews with Leila Williams Carlo.

Page 110: Background information from interviews with Leila Williams Carlo.

Page 111: Background information from National Archives and Records Administration files.

Relying on Each Other

Page 117: Background information courtesy of Olive Megchelsen.

Page 121: Background information provided by Norma Schweitzer and Valeen Ziegenhorn of the Louisa County Historical Society.

Page 123: Identification and background information provided by Catherine Curtis Seyb.

Page 125: Background information provided by Geraldine Middleswart.

Page 126: This may have been the Alfred Keith farm, near Wayland. The auctioneer shown in the photo is Dan Roth, now deceased. Background information from Glen Widmer.

Bibliographical Essay

There are several very useful texts on the history of farming and on the people who lived and worked on farms during the years Pete Wettach traveled with his camera. R. Douglas Hurt's *American Agriculture: A Brief History* (Ames: Iowa State University Press, 1994) provides an excellent overview; Earle Dudley Ross's *Iowa Agriculture: An Historical Survey* (Iowa City: State Historical Society of Iowa, 1951) and the Iowa State College staff's *A Century of Farming in Iowa, 1846–1946* (Ames: Iowa State College Press, 1946) are solid sources of detailed information. Don Muhm's *Iowans Who Made a Difference: 150 Years of Agricultural Progress* (West Des Moines: Iowa Farm Bureau Federation, 1996) provides background on the personalities that shaped this era. Mary Neth's fascinating book on farm women, *Preserving the Family Farm: Women, Community, and the Foundations of Agribusiness in the Midwest, 1900–1940* (Baltimore: Johns Hopkins University Press, 1995), is packed with facts, figures, historical analysis, and personal stories about women in agriculture as well as good information on children's contributions to the farm economy and the supportive interconnections between rural neighbors. Margaret Atherton Bonney's booklet titled *Women: Partners on the Land* (Mount Pleasant, Iowa: Midwest Old Threshers, ca. 1985) is a concise and detailed description of the experiences of rural Iowa women in the late nineteenth and early twentieth centuries. Hans Halberst's *Threshers at Work* (Osceola, Wisconsin: Motorbooks International Publishers and Wholesalers, 1997) presents a good photographic look at some of the machinery and activity around early threshing. Leola Nelson Bergmann's booklet, *The Negro in Iowa* (Iowa City: State Historical Society of Iowa, 1969, first published in 1948 as an article in v.46 of the *Iowa Journal of History and Politics*), although written more than half a century ago, takes a close look at census and other data on African American communities in Iowa to construct an informative history in a way that has not been repeated since. A new biography of Henry A. Wallace by former U.S. Senator John C. Culver and journalist John Hyde, *American Dreamer: The Life and Times of Henry A. Wallace* (New York: Norton, 2000), is a very well written and informative account of the political realities around American agriculture in the early twentieth century and of the man who did so much to shape farm policy and technology. Sidney Baldwin's *Poverty and Politics: The Rise and Decline of the Farm Security Administration* (Chapel Hill: University of North Carolina Press, 1968) probes more deeply into the people and politics behind the controversial FSA programs.

Many, many compilations of black-and-white photography, both historic and modern, inspired this book. A few are worth mentioning here as particularly influential. Earl Dotter's *The Quiet Sickness: A Photographic Chronicle of Hazardous Work in America* (Fairfax, Virginia: American Industrial Hygiene Association, 1998) served as the original inspiration for a book linking science and art. The collection of images from glass plate photographs in John Carter's *Solomon D. Butcher: Photographing the American Dream* (Lincoln: University of Nebraska Press, 1985) and Mary Bennett's *An Iowa Album: A Photographic History, 1860–1920* (Iowa City: University of Iowa Press, 1990) are both beautiful presentations of photographs from eras predating Wettach's career. Conversations with Mary Bennett and with Abigail Foerstner, author of *Picturing Utopia: Bertha Shambaugh and the Amana Photographers* (Iowa City: University of Iowa Press, 2000) provided valuable insight into my own effort to complete a book. Another University of Iowa Press book, *The Lincoln Highway: Main Street across America* by Drake Hokanson (1999), is an excellent example of the use of storytelling and photography in a book. Richard Whelan's *Double Take: A Comparative Look at Photographs* (New York: C. N. Potter, 1981) is a useful text on understanding photography as an art form, while *Documenting America, 1935–1943*, edited by Carl Fleischhauer and Beverly W. Brannan (Berkeley: University of California Press, 1988), focuses specifically on the work of the FSA photographers. The seminal book *Let Us Now Praise Famous Men* (Boston: Houghton Mifflin, 1941), with text by James Agee and photographs by Walker

Evans, shows how one FSA photographer sought to present his pictures of rural families.

Some genres of photography relate more closely to the kind of pictures Pete Wettach took. Among the most similar are the pictures of J. C. Allen & Son, Inc., a family business that has been producing farm photographs since the early 1900s. These photographs show many parallels in style and subject matter to Wettach's earlier work. The Allen family has put together several books, including *Farming Comes of Age: The Remarkable Photographs of J. C. Allen & Son, 1912–1942* (Louisville, Kentucky: Harmony House, 1995), *Farming Once upon a Time: More Remarkable Photos by J. C. Allen & Son* (Louisville, Kentucky: Concord Publishers, 1996), and *Pictures from the Farm: An Album of Family Farm Memories* by John O. Allen and Amy Rost-Holtz (Stillwater, Minnesota: Voyageur Press, 2001).

Published personal memoirs of midwestern farm life helped shape and define many of the subjects presented in this book. Steven R. Hoffbeck's *The Haymakers: A Chronicle of Five Farm Families* (St. Paul: Minnesota Historical Society Press, 2000) combines history and memoir to describe the evolution of technology and culture in hay production in the Midwest. Kenneth Hassebrock's *Rural Reminiscences: The Agony of Survival* (Ames: Iowa State University Press, 1990) filled some gaps in my understanding of the daily life of a farm child in Iowa. The beautifully written and illustrated book *Clabbered Dirt, Sweet Grass* by Gary Paulsen (New York: Harcourt Brace Jovanovich, 1992) and the funny and poignant stories in Jim Heynen's *The One-Room Schoolhouse: Stories about the Boys* (New York: Alfred A. Knopf, Inc., 1993) are wonderfully evocative prose portraits of farm life. These last three books, as well as other books by Jim Heynen about "the boys," may be of particular interest to readers who are looking for nostalgic works about growing up on a farm.

Identification of farm tractors and machinery proved to be enormously helpful in estimating dates on undated photos. I relied heavily on experts — farmers or former farmers and the staff of the Midwest Old Threshers Museum — as well as the following texts, both published by the American Society of Agricultural Engineers in St. Joseph, Michigan: *Farm Tractors: 1950–1975* by Lester Larsen, 1981 and *The Agricultural Tractor: 1855–1950*, by Roy Burton Gray, 1954. For the oldest machinery, *Farm Power in the Making of America* by Paul C. Johnson (Des Moines: Wallace-Homestead Book Co., 1978) is a good resource.

Written information contributing to the development of Pete Wettach's biography included portions of an unpublished autobiography by his son, Robert S. Wettach, and the employee file for Arthur Melville Wettach from the National Personnel Records Center, National Archives and Records Administration, St. Louis, Missouri.

Documentation on some of the families in the Tenant Purchase program was found at the National Archives Great Lakes Region, RG 96, Records of the Farmers Home Administration, Region 3, Records of the Rural Rehabilitation Division, Farm Ownership Case Files, 1937–1946, Entry 53, Herbert F. Rummel, #16-33-200614; Arthur Conard, #16-44-222059; Ralph D. Mann, #16-51-224467; Boyd K. Brown, #16-44-221715. Historians and genealogy buffs may be interested to know that, despite the enormous amount of detailed information in these files, they have remained nearly untouched for years.

A few miscellaneous texts were very helpful to my research. *Children of the Land: Adversity and Success in Rural America* by Glen H. Elder, Jr., and Rand Conger (Chicago: University of Chicago Press, 2000) provided a link from the modern experience of the family farm to that recorded by Wettach. A new printing of the old 1913 *Handy Farm Devices and How to Make Them* by Rolfe Cobleigh (originally published New York: Orange Judd Co.; reissued New York: Lyons Press, 1996) and similar books in that series provided a nuts-and-bolts look at everyday problems for farmers. Finally, an article that I wrote for *Iowa Heritage Illustrated*, the quarterly magazine of the State Historical Society of Iowa ("Children on the Farm: Through the Lens of Photographer A . M. Wettach," vol. 81, no. 1, Spring 2000), provided the base from which I developed the chapter on children in this book.

Index